IMAGES
of America

FRONTIER FORTS
OF TEXAS

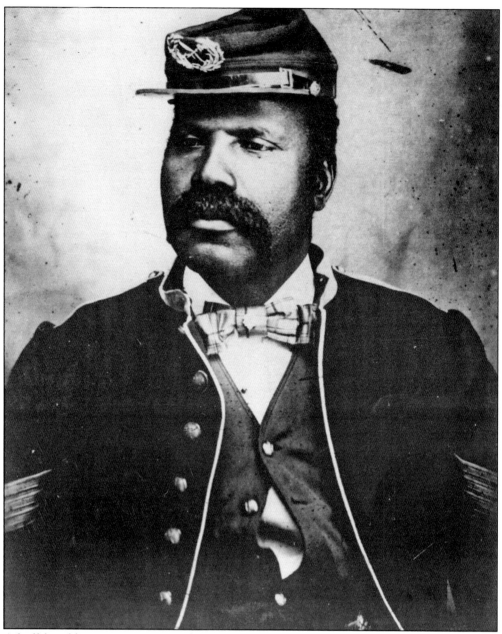

A buffalo soldier sergeant poses with a sporty addition to his uniform. All four buffalo soldier regiments—the 9th and 10th Cavalry and the 24th and 25th Infantry—served with distinction in Texas during the Indian Wars. (Courtesy of the National Archives and Records Administration.)

ON THE COVER: A Spanish presidio was erected in 1757 to protect Mission San Saba from Comanche raiders. But the large war party that arrived in 1758 skirted this formidable fortification and launched a direct assault on the nearby frontier mission. (Author's collection.)

IMAGES of America
FRONTIER FORTS OF TEXAS

Bill O'Neal

ARCADIA
PUBLISHING

Copyright © 2018 by Bill O'Neal
ISBN 978-1-4671-2859-9

Published by Arcadia Publishing
Charleston, South Carolina

Printed in the United States of America

Library of Congress Control Number: 2017956392

For all general information, please contact Arcadia Publishing:
Telephone 843-853-2070
Fax 843-853-0044
E-mail sales@arcadiapublishing.com
For customer service and orders:
Toll-Free 1-888-313-2665

Visit us on the Internet at www.arcadiapublishing.com

For Karon Ashby O'Neal, my companion and photographer on fort trips across Texas and the American West.

Contents

Acknowledgments		6
Introduction		7
1.	Presidios and Private Forts	9
2.	US Army on the Texas Frontier	17
3.	The Border Forts	47
4.	New Forts in West Texas	57
5.	Post–Civil War Rebuilding	83

ACKNOWLEDGMENTS

My first debt of gratitude is to Caitrin Cunningham, senior title manager at Arcadia Publishing. My initial contact about *Frontier Forts of Texas* was with Caitrin, and she has guided this project from start to finish. Arcadia maintains a tight publication schedule, and in five previous titles, I had never missed a deadline. But this sixth Arcadia title suffered two major roadblocks. Caitrin was the essence of understanding and tact, and without her patient persistence, this book could not have been completed.

Throughout our marriage, my wife, Karon, traveled with me to historic sites across the United States. Frontier military forts were always high on my list, and after becoming Texas state historian, my travels focused on the Lone Star State. I had taken college students to some of the best frontier forts for 20 years in my traveling Texas history course, and Karon always drove one of the college vans. She urged me to put together a book about the frontier forts of Texas, and she assisted with this project in many ways.

My eldest granddaughter, Chloe Martinez, agreed to produce a manuscript on short notice. A second-year college student, Chloe has assisted me on previous book projects, but this time we faced a rigid deadline. She developed a manuscript rapidly and expertly, and I could not have completed this project without her. Shay Joines, a Panola College student and library assistant, provided invaluable technological assistance in arranging the photographs. My daughter, Dr. Berri O'Neal Gormley, came to my rescue as photo editor with the 208 images used in this book.

At Fort McKavett Park, superintendent Buddy Garza offered enthusiastic assistance and provided a golf cart for Karon to maneuver around the extensive grounds. Other welcome help came from Ann Nelson, Carole Goble, and Milli Williams at Fort Croghan; Janie Lenoir at Fort Griffin; Wilson White at Fort Lancaster; Eddie Perez at Fort Belknap; Dr. Lacey Johnson at Fort Stockton; and Garland and Lana Richards and Ann Pate at Fort Croghan. I am grateful to two Carthage friends, Dennis LaGrone and his lovely daughter Ashley LaGrone Brewster, for making it possible for me to photograph his Spencer carbine for this book.

INTRODUCTION

Texas, with its vast size and long frontier period, was the scene of more combat events between Indians and Anglo settlers or soldiers than any other state or territory. A survey of such combat determined that Texas was the site of at least 846 fights between the warring races. Arizona Territory was the scene of more than 400 clashes—the second-highest total—while more than 300 actions were fought in New Mexico. In 1866, Texas Rangers as well as civilians and soldiers engaged in 61 fights against warriors—the most in a single year—and in 1867, there were 40 combats. The final conflict of the Indian Wars in the Lone Star State was fought in West Texas in 1881.

Anglo settlers began moving into Texas during the 1820s. As conflict with native tribes began, settlers "forted up," while mounted fighting men launched the tradition of Texas Rangers. The most elaborate settlers' fort was stockaded Fort Parker, erected by the Parker clan. But in 1836, a large war party struck Fort Parker. Several settlers were slain and among the captives taken was nine-year-old Cynthia Ann Parker, who would become the mother of the last great Comanche chief, Quanah.

The US Army marched into Texas in 1846, shortly after the Lone Star Republic became the 28th state in the Union. War with Mexico erupted, and Fort Brown, near the mouth of the Rio Grande, became the first of many military installations in Texas to be built and manned by the US Army. At the end of the Mexican-American War, in 1848 and 1849 the Army established forts along the Rio Grande to protect the border. For decades, soldiers from the border forts struggled against smugglers, bandidos, rustlers, and revolutionaries.

Meanwhile, a north-to-south line of forts was built to screen the frontier from the raids of horseback warriors. Beginning with Fort Worth and extending to Fort Martin Scott near Fredericksburg, this line of forts proved short-lived. Settlers rapidly moved past these forts, which were abandoned within a few years as a new line of forts was erected farther to the west. Another set of forts was erected to protect a stagecoach line to California that angled north to southwest as far as El Paso and beyond.

All of these forts were constructed largely by troop labor. Although craftsmen, such as stonemasons, sometimes were employed, troopers often spent far more time erecting buildings than drilling or patrolling. Soldiers constantly griped that they had not enlisted to be construction workers. But each garrison represented a sizeable labor force, available at no extra cost to the Army.

The introduction of an Army post to a frontier area brought economic transformation. Soldiers needed fresh vegetables and meat, and cavalry horses required grain and hay. Near the military reservation, a "hog ranch" provided earthy recreation for the soldiers. Towns began to grow near the forts, and many became county seats. Indeed, the courthouse square of Fort Worth was the old parade ground. The towns of Fort Davis, Fort Stockton, Fort McKavett, and even Brownsville took their names from adjacent military posts. Brave little population centers grew in the vast, empty frontier of Texas because of nearby military outposts.

There was a great deal of action against war parties during the 1850s. The innovative secretary of war Jefferson Davis organized and equipped and selectively manned a cavalry regiment designed to battle horseback warriors on their own terms. The frontier forts of West Texas thus became bases from which cavalry columns launched patrols or pursuits. Another innovation of Secretary of War Davis's was camels, imported to replace packhorses and mules in the arid Southwest.

US Army activities in Texas abruptly ended in the spring of 1861. With the outbreak of the Civil War, federal troops abandoned the forts and were taken by ships to the United States. (Texans who had enlisted locally left the Army and stayed in the Lone Star State.) Texas was the only state in the Confederacy with a frontier exposed to Indian attack, and Comanche war parties raided the undefended frontier counties. Small contingents of the state's Frontier Regiment or of Texas Rangers or of county militias reoccupied some of the abandoned outposts, which fell into disrepair during the war years.

At the close of the Civil War, the US Army was greatly reduced and, accordingly, reorganized. Within a year after Appomattox, demobilization returned nearly one million men to civilian life, and in 1866, Congress authorized a force of 54,302 officers and enlisted men. Further reductions came in 1869, with infantry regiments cut from 45 to 25 and an authorized strength of 37,313 men. In 1874, the number of enlisted men was further cut to 25,000 soldiers, with an additional 2,000 officers. But with a large West Point detachment, recruiting details throughout the nation, Leavenworth Prison guards, and departments of engineers, commissary, quartermaster, ordnance, and medical, regimental rolls totaled no more than 19,000 men. Along with 25 infantry regiments, there were 10 cavalry regiments and five artillery regiments.

Cavalry regiments had 12 companies each, infantry regiments just 10. Counting men who were on sick call or extra duty or incarcerated, companies never were at more than three-quarters strength, and sometimes only a handful of men reported for duty call. Each company was divided into two platoons. A troop was officered by a captain, a first lieutenant, and a second lieutenant. But officers often were on court-martial duty at another post, or on some other detached service or on extended leave. All too frequently, only one officer was available as company commander. With companies so often understrength, and with many outposts garrisoned by just one cavalry and one infantry company, in times of alarm a troop or two would have to be sent from another fort. Indeed, transportation costs often were major expenditures on the frontier.

With the end of the Civil War in 1865, the US Army returned to Texas as occupation troops during Reconstruction. During and after the Civil War, with the US Army elsewhere, Comanches struck hard, driving the frontier line back as far as 100 miles and forcing the abandonment of three out of four ranches. In 1867, the US Army returned to the frontier. The long-abandoned pre–Civil War forts had deteriorated badly, but many were rebuilt, larger and better than ever before. In addition, three new forts were established on the Texas frontier: Fort Richardson, Fort Griffin, and Fort Concho. Operating from spacious and improved outposts, federal troops assaulted the "Wild Tribes"—Comanches and Kiowas. A man considered the Army's best postwar regimental commander—Civil War hero Ranald Mackenzie—was sent to Texas with his crack 4th Cavalry regiment. Year after year, Colonel Mackenzie aggressively led hard-hitting campaigns, which climaxed in the Red River War of 1874–1875.

The Army's success in the Red River War drove Comanches and Kiowas onto adjacent reservations in western Indian Territory. Occasionally, a few warriors slipped away from their reservation, but usually they created little trouble. Buffalo were disappearing from Comancheria, and with the old way of life no longer possible, military campaigns became an activity of the past.

The new or expanded forts of the post–Civil War frontier began to close. Fort Richardson, after only 10 years of existence, was deactivated in 1878. Another one of the new posts, Fort Griffin, was closed in 1881. Two years later, the Army pulled out of Fort McKavett. Fort Stockton was deactivated in 1886, Fort Concho in 1889, and Fort Elliott in the Panhandle in 1890. The following year, sprawling Fort Davis was deactivated. When the Army abandoned frontier forts, nearby settlers were quick to engage in "midnight requisitioning," stripping fort structures of doors, windows, shingles, and other building materials. Smaller frame structures often were hauled off to someone's ranch.

While most of these posts were deactivated before the end of the 19th century, a few border forts—Brown, Ringgold, Duncan, McIntosh, Clark, and Bliss—continued into the next century. By the end of World War II, all were closed except for Fort Bliss, a large and important base today. Numerous buildings from the 19th century still are utilized at Fort Bliss, and there is an excellent replica of early Fort Bliss on the base. While some of the Texas frontier forts have completely disappeared—Fort Worth, for example, as well as Elliot, Quitman, Gates, and Graham—a majority of the old posts are represented today by ruins and restored buildings. Fort Davis, a National Historic Site, has been superbly rebuilt at its picturesque location. Other outstanding reconstructions include Forts Concho, McKavett, Richardson, Stockton, and Martin Scott. The most haunting sets of ruins are at Fort Phantom Hill, with its lonely chimneys, and Fort Lancaster, with stone remains in a magnificent setting. At these and a score of other historic military sites, the uniformed ghosts can be felt among the structures where they once ate and slept and drilled.

One

PRESIDIOS AND PRIVATE FORTS

The first military forts in Texas were presidios, built during the 1700s by the Spanish to protect nearby frontier missions. Spain established 25 missions in the province of Texas, and several of these missions were moved to different locations. Presidios were not erected at all mission sites, only those deemed most exposed to attack by hostile Indians, especially the ferocious horseback warriors of the Comanche tribes. A number of presidios were small and constructed of logs or adobe. A common plan featured two corner bastions at opposite ends of the walls (northwest and southeast corners, for example), so that soldiers could shoot along all four walls from just two bastions.

But the Presidio La Bahia was a complex fortification of stone construction, with watchtowers and cannon emplacements. The most formidable presidio in Texas, La Bahia was a focal point of several conflicts, most tragically the massacre of Col. James Fannin and almost 400 Anglo soldiers during the Texas Revolution. Another murderous event surrounded the presidio built to protect Mission San Saba on the edge of the Texas frontier of the 1750s, when a massive war party overwhelmed all defenses.

The soldiers who manned frontier presidios were called *presidiarios*. It was hard to garrison isolated outposts, and *presidiarios* often were criminals who agreed to 25-year enlistments on the frontier in order to avoid execution or long terms in notorious Mexican prisons. Mission priests often found *presidiarios* to be a mixed blessing, military men who drank and stole and tried to romance newly Catholicized mission girls.

The most famous Spanish "fortress" in Texas was a mission compound built without fortifications. Mission San Antonio de Valero was established in 1718. Soon it was nicknamed "Alamo" because of the presence of cottonwood trees alongside the nearby San Antonio River. But the mission was closed in 1793, and by the time of the famous 1836 battle, the low walls were crumbling and there still were no loopholes or towers. The sprawling, unfortified old mission and its 200-man garrison were overwhelmed by a superior force and slain to a man.

The first Anglo fortifications in Texas were private forts, often only a blockhouse where neighbors could gather in times of alarm. The most elaborate of these private strongholds was Fort Parker, featuring a tall, loopholed stockade and two stout blockhouses. Unfortunately, the walls were undefended, and the heavy gate was wide open when a large war party attacked.

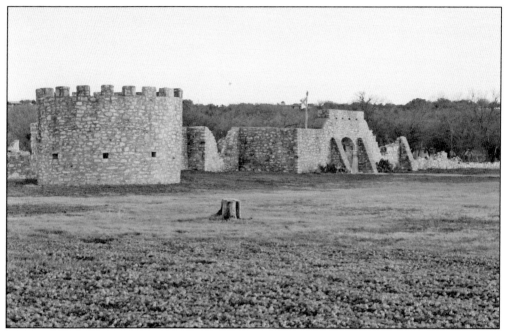

In 1754, Spanish missionaries founded Mission San Saba on the edge of Comancheria. Col. Diego Parillo brought 100 men in 1757 to build a presidio just north of the San Saba River and about a mile from the mission. Fortifications included a stone tower, or *torreón*, and a fortified gate. (Author's collection.)

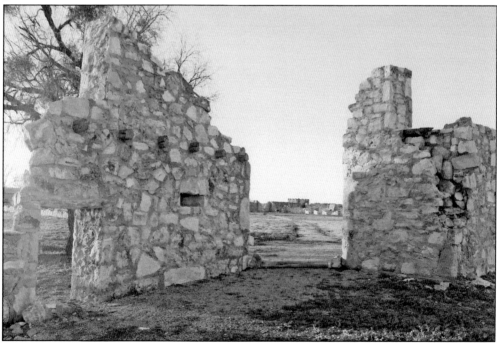

The compound also boasted a bastion beside the river. But in 1758, an immense war party estimated at 2,000 bypassed the presidio and struck the mission. Priests and soldados were killed, and the looted mission was abandoned. (Author's collection.)

When Mission San Saba was being established, 24 men were dispatched to open a mine shaft at a promising rock formation to the west. The ore had traces of silver, and after the mission was abandoned, the Lost San Saba Mine became a constant temptation. But when 11 Hispanic prospectors located the site in 1779, they were struck by Comanches and only one man survived. (Author's collection.)

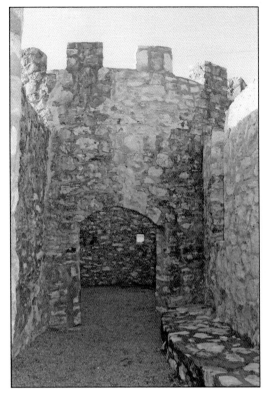

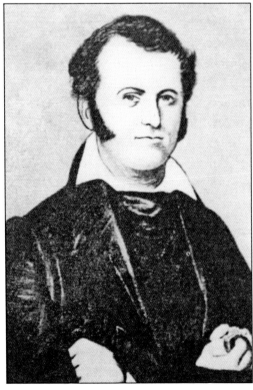

Frontier adventurer James Bowie lusted to find the silver mine and had no fear of hostile war parties. In 1831, he led 11 men out of San Antonio and past the ruined mission. But before finding the mine site, the party was struck by more than 100 Comanches. Fighting lasted for 10 hours. One of Bowie's men was killed and five wounded, but Comanche losses were far heavier, and they withdrew after dark. (Author's collection.)

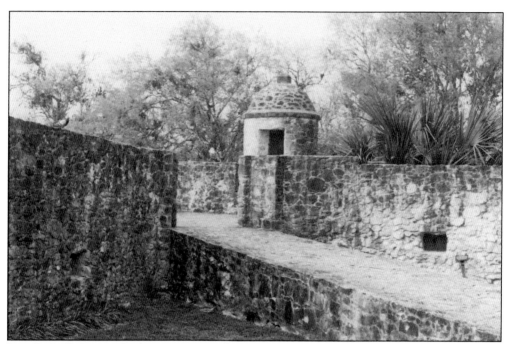

Presidio La Bahia was built to protect nearby Mission La Bahia, as well as Mission Rosario a few miles to the west. When stone construction was completed, the fortification was the strongest presidio in Texas. There were cannon emplacements and watchtowers (above) and stone barracks and storehouses (below), in addition to a chapel. Even after the missions closed, the stout old presidio was a point of conflict of the Gutierrez-Magee Expedition (in 1812–1813), the filibustering expeditions of Henry Perry (1817) and Dr. James Long (1821), and—most notably—Col. James Fannin's command during the Texas Revolution (1835–1836). (Both, author's collection.)

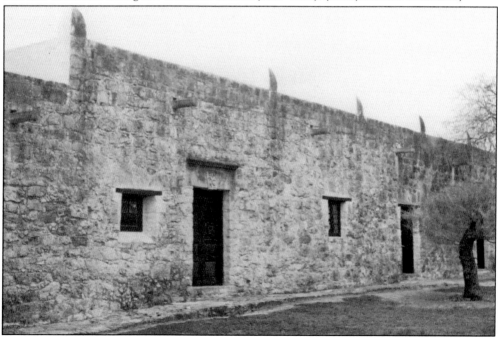

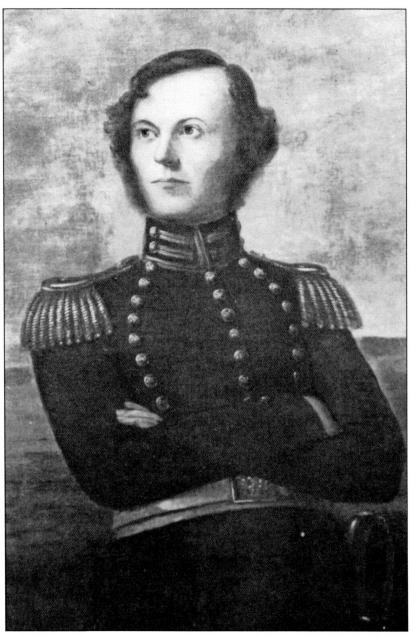

Col. James W. Fannin had spent two years at West Point before dropping out, but during the revolution against Mexico he was one of the few Texans with military training. Early in 1836, as the Mexican army marched into Texas, Colonel Fannin commanded the largest force of Texans, 400 men headquartered at the presidio at Goliad, now named Fort Defiance. Fort Defiance was a far stronger fortification than the Alamo, a decaying old mission, which fell to Gen. Santa Anna on March 6. But when several hundred Mexican lancers approached Goliad on March 19, Colonel Fannin abandoned Fort Defiance the next day and began a deliberate retreat. Soon surrounded in an open field, Fannin surrendered unconditionally. Fannin and his men were incarcerated in the old presidio, and on Palm Sunday, March 27, they were marched out and shot. (Author's collection.)

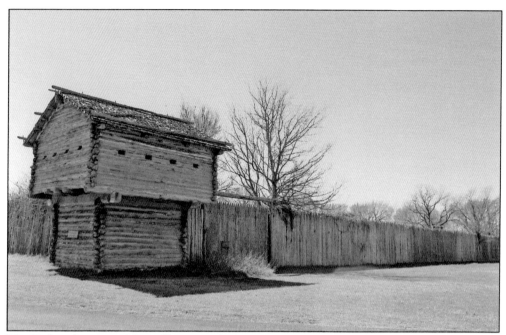

The Parker clan moved from Illinois to the Mexican province of Texas in 1832. Late the next year, construction began on a private fort near the Navasota River. Split logs were sunk three feet into the ground, forming a stockade 12 feet tall. Fort Parker was completed in March 1834, and several families moved into the one-room cabins that lined the front and rear walls. (Author's collection.)

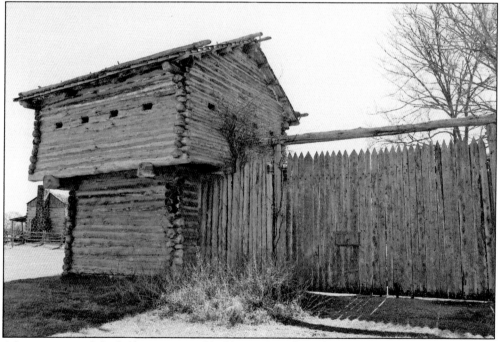

A heavy gate was defended by a two-story blockhouse. But when a large war party attacked on May 19, 1836, the gate was wide open and warriors galloped into the compound. (Author's collection.)

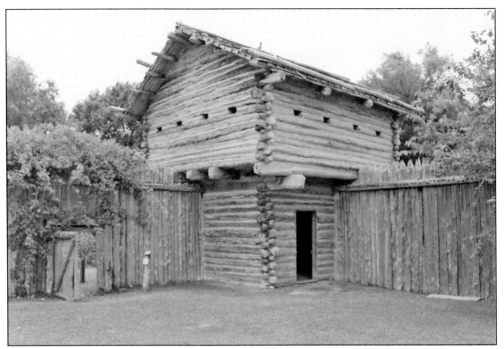

A second blockhouse was built at a diagonal corner, so that all four walls could be covered from the second story of one of the two blockhouses. Four cabins were aligned along the rear wall, two along the front, and the stockade formed the back wall of each cabin. (Author's collection.)

The stockade walls were loopholed with firing platforms. But on the day of the attack, most of the men were in the fields when Comanche warriors raced through the gates. Although some escaped through a small gate beside the rear blockhouse, five men were slain and five captives were seized. (Author's collection.)

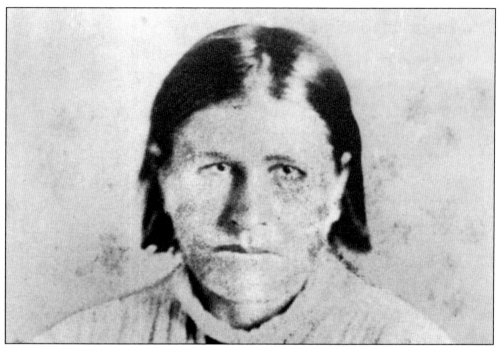

Cynthia Ann Parker was nine in 1836 when she was carried away from Fort Parker by Comanche warriors. She adapted to the Comanche lifestyle, darkened her hair with buffalo dung, and bore three children to Chief Peta Nocona. The eldest of her children, Quanah, became the last great chief of the Comanches. Cynthia was recaptured by Texas Rangers in 1860, but she spent the rest of her life trying to return to the Comanches. (Author's collection.)

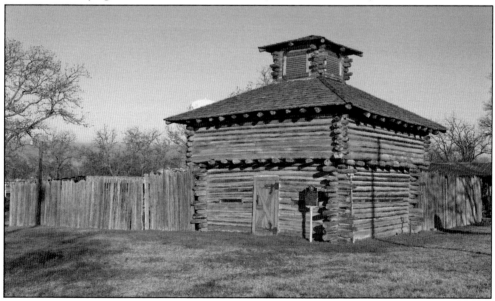

Here and there across the Texas frontier, isolated settlers would erect a blockhouse as a neighborhood refuge in times of alarm. A fine example is Fort Inglish, built by pioneer Bailey Inglish about 1838 beside his log cabin. The stout blockhouse also featured an adjoining stockade and became the nucleus of the settlement known as Bonham. (Author's collection.)

Two

US Army on the Texas Frontier

Texas became the 28th state in the Union early in 1846, and soon war with Mexico broke out along the new, and bitterly contested, international border—the Rio Grande. Near the mouth of the Rio Grande, Fort Brown became the first of many outposts of the US Army in Texas. After the victorious invasion of Mexico, the US Army established a series of posts along the Rio Grande, from Fort Brown all the way to Fort Bliss at El Paso del Norte.

Texas became the fastest-growing state in the Union, with a population that tripled during the decade of the 1850s. As Texans moved westward, they engaged in vicious warfare against the "Wild Tribes"—Comanche and Kiowa horseback warriors. These horseback warriors were armed with bows and arrows, a repeating weapon that could be fired from a galloping horse. Settlers were at serious disadvantage with single-shot, muzzle-loading firearms. But in the 1840s, Texas Rangers began to use cap-and-ball revolving pistols—a repeating weapon that could be fired from a galloping horse. The Army soon would find itself strongly influenced by Texas Ranger tactics.

Simultaneously with the establishment of border forts along the Rio Grande, the US Army began to place a line of outposts across the rapidly advancing Texas frontier. This initial line of posts, from Fort Worth to Fort Martin Scott, soon became obsolete, and within a few years, another line was established. Farther west, other isolated forts were established to protect the military road to El Paso and the stagecoach road to California.

These early posts were not substantially built, with adobe, log, or picket (logs placed vertically) construction prevailing. Roofing often was canvas or brush. There were no fortifications—blockhouses or stockaded walls—at these "forts." The Army quickly learned that hit-and-run warriors had no intention of attacking a military base. Instead of living inside a cramped stockade, "forts" became military towns spread out around a parade ground. (The exception that proves the rule occurred at Fort Lancaster in 1867, when an outnumbered garrison of buffalo soldiers was formed into skirmish lines and fought off an attack on foot.)

Some of these early forts were discontinued before the Civil War, and all were abandoned during the war. These empty posts deteriorated rapidly, but after the war, several were reoccupied and rebuilt. Already the site of prewar military activities, these refurbished forts once again played a role in settling the Texas frontier.

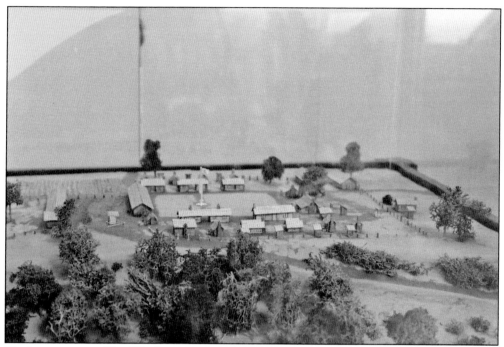

The log structures of Fort Worth were arranged around a parade ground, but the post was abandoned in 1853 as the frontier moved west. The fort buildings were appropriated for commercial use, and the parade ground became the courthouse square for the growing community of Fort Worth. (Scale model in Fort Worth's Fire Station No. 1 Museum, author's collection.)

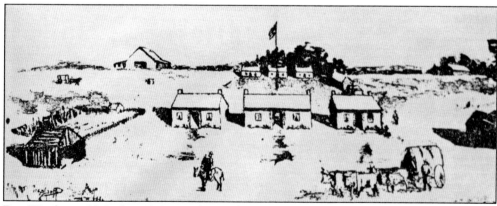

Fort Worth, established in 1849, was the northernmost outpost in the first line of military forts built to screen the Texas frontier. Named after Gen. William Worth, a hero of the War with Mexico, the post was located on the windswept south bank of the Trinity River. Dragoon stables and corrals were built near the riverbank, and horses were led to water down steep, 150-foot paths. (Courtesy of the *Fort Worth News-Tribune*.)

Fort Gates was the last of the initial line of frontier forts to be established, in October 1849, on the north bank of the Leon River. There were 18 buildings: four officers' quarters, two company barracks, a hospital, a guardhouse, a bakery, a stable, a blacksmith shop, and three warehouses, as well as a circular stockade. The post was abandoned in 1852, but no traces remain today. (Photograph by the author of a Texas State Historical Marker placed in 2006 by the Texas Historical Commission.)

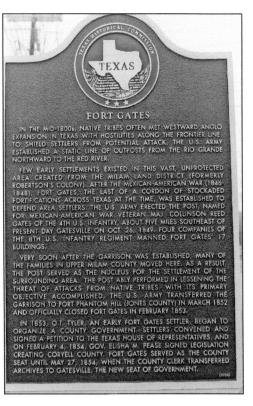

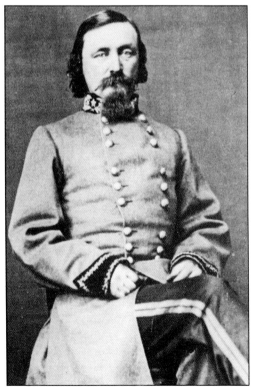

At Fort Gates in November 1851, Sally Pickett, wife of Lt. George Pickett, died in childbirth. The young couple had been married only since January. Pickett graduated last in his West Point class of 1846, but he performed heroically during the War with Mexico. He served on the Texas frontier from 1849 through 1855, rising to captain of infantry. As a Confederate general during the Civil War, Pickett famously led a doomed charge at Gettysburg. (Courtesy of the National Archives and Records Administration.)

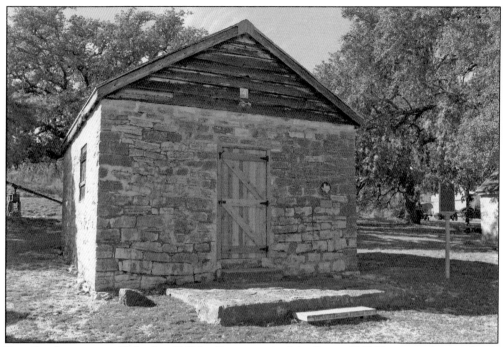

Fort Croghan was established in 1849 by Company A of the Second US Dragoons. Log and rock structures were erected on the west bank of spring-fed Hamilton Creek. The limestone building shown above served as post headquarters. Four log officers' quarters were customary dog run cabins, with two rooms divided by a roofed breezeway, or dogtrot. The log hospital had four rooms. (Author's collection.)

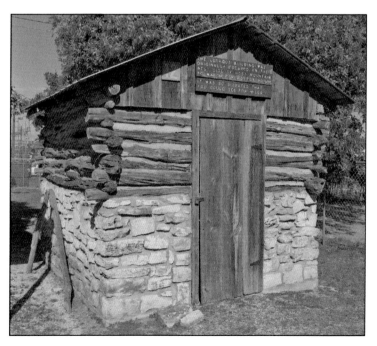

Aside from the post headquarters, the only other surviving structure is a sentinel hut, erected atop nearby Post Mountain to look out for war parties. After Fort Croghan was abandoned in 1855, settlers of Burnet, across Hamilton Creek to the east, appropriated the hospital and other buildings for private use. (Author's collection.)

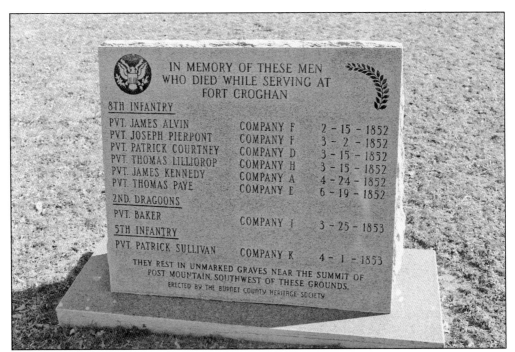

Eight soldiers died while on duty at Fort Croghan. Although buried at a little cemetery on Post Mountain, the graves became lost. In 1989, the Burnet County Heritage Society erected a monument listing the name, rank (all were privates), company, and demise date of each man. (Author's collection.)

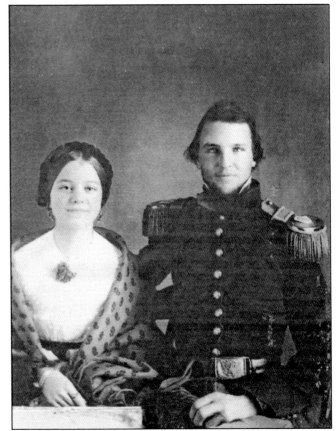

Attired in his dress uniform, an unidentified officer and his bride happily pose for a portrait. Three other officers who also served at Fort Croghan became generals during the Civil War. Philip St. George Cooke and H.H. Sibley, who invented the conical Sibley tent, both served as post commander. Maj. Albert Sidney Johnston, in his capacity as paymaster, visited Croghan throughout the life of the fort. (Courtesy of the Fort Croghan Museum.)

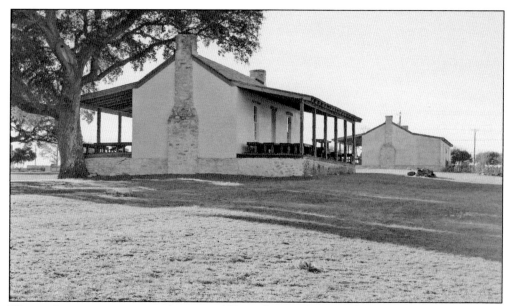

The southernmost outpost in the original Texas frontier line of federal forts was established in December 1848 on Barons Creek, about two miles southeast of the village of Fredericksburg. Settled by German immigrants only two years earlier, Fredericksburg was struggling for survival when Fort Martin Scott (named for an infantry major slain during the War with Mexico) created employment for local farmers, freighters, and craftsmen—to build structures such as officers' quarters. (Author's collection.)

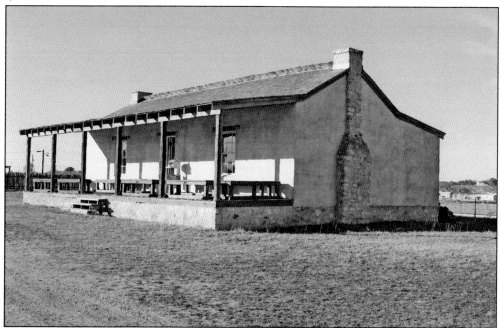

Officers' Row consisted of six houses on the north side of the parade ground, facing south. The west side of the rectangular parade ground was dominated by the commanding officer's quarters, a log structure measuring 34 feet by 30 feet, including galleries (or porches) at front and rear. (Author's collection.)

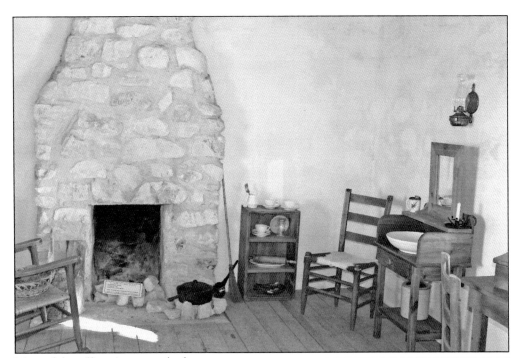

Most of the officers' quarters had at least two rooms bisected by a central hallway. One officers' quarters, however, was a one-room frame house measuring just 17 feet by 16 feet. The two sets of officers' quarters still standing on Officers' Row have been restored. (Author's collection.)

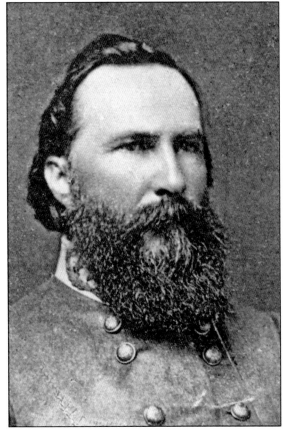

One of the officers' quarters at Fort Martin Scott was inhabited by James and Maria Longstreet and their growing family. A graduate of West Point and a wounded hero of the War with Mexico, Longstreet served with the 8th Infantry in Texas. Later transferred to Fort Bliss, Longstreet was promoted to major and paymaster in 1858. During the Civil War, General Longstreet became known as the best corps commander in the Confederate army. (Courtesy of the National Archives and Records Administration.)

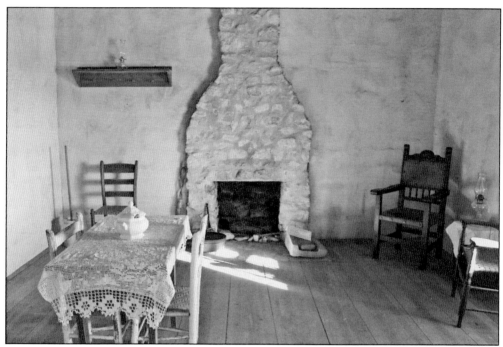

Rooms in the officer's quarters were sparsely furnished. During the late 1840s and early 1850s, it was difficult to bring furniture to the Texas frontier. Simple items might be crafted on the post, or purchased in Fredericksburg. But when the officer was transferred, he customarily left behind the rudimentary furnishings he (or his wife) had accumulated. (Author's collection.)

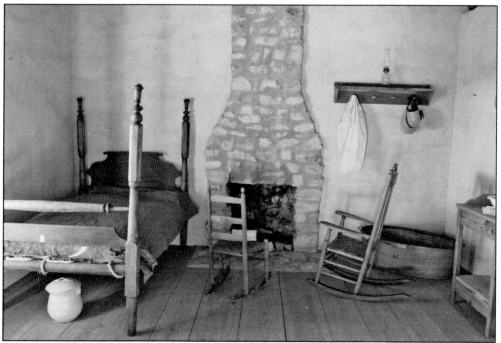

Amenities in this bedroom include a chamber pot beneath the bed, a washstand, and a government-issued bathtub. (Author's collection.)

Four company barracks were built on the south side of the parade ground, and one has been restored. The rear of this barracks led to the stables and to the quartermaster storehouse, which was the largest building on the post (18 feet by 78 feet). In addition to an infantry company or two, dragoons usually were stationed at Fort Martin Scott, and the stable area included a barn with stalls. (Author's collection.)

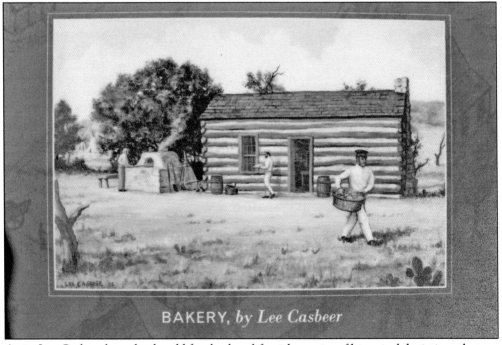

Artist Lee Casbeer brought the old fort back to life with a series of historical depictions that are displayed around the base. For example, Casbeer reproduced the post bakery, which was one of the first structures completed—because the soldiers building the fort had to eat. (Courtesy of Fort Martin Scott Historical Park.)

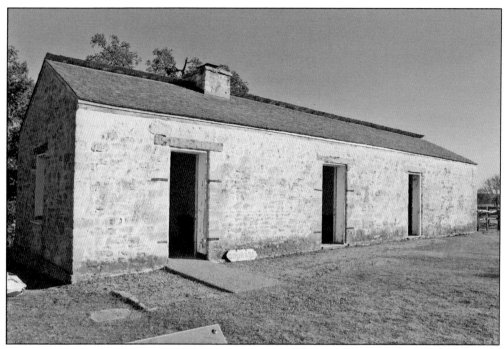

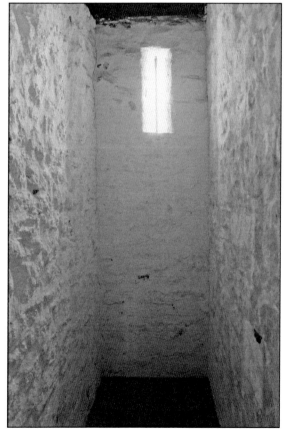

The guardhouse is the only building at Fort Martin Scott to survive intact because the stout stone structure long was utilized by a farmer. Located at the eastern end of the parade ground, the guardhouse featured an office for the officer of the day (through the door at left), the guard's sleeping quarters (center door), and the dayroom (door at right). (Author's collection.)

The cell block contained four narrow cells, each less than three feet wide, where prisoners slept in decidedly cramped quarters. (Author's collection.)

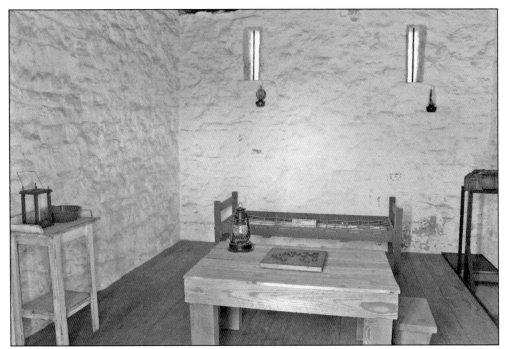

The dayroom opened into the cell block. Prisoners took their meals in the dayroom and sometimes enjoyed a little leisure time, when not being supervised on work details. In addition to guardhouse confinement, punishments included fines, reduction in rank, lashes from a rawhide whip, hanging by the thumbs, and being branded on the hip with a "D" (Drunkard) or "T" (Thief). (Author's collection.)

Restoration work at Fort Martin Scott has included rebuilding the low picket fence that surrounded the military reservation. The post was approached from the east, and occasionally, there were as many as 300 men at the fort. But there was scant Indian trouble in the area, and Fort Martin Scott closed in 1853, after only five years of military occupation. (Author's collection.)

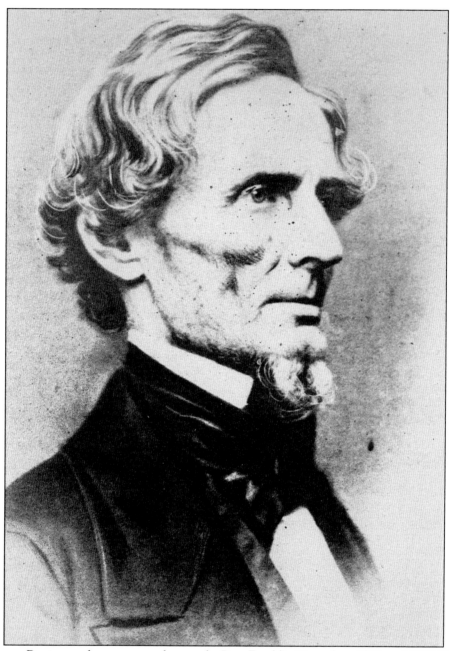

Jefferson Davis served as secretary of war under Pres. Franklin Pierce from 1853 until 1857. Davis had a strong military background: West Point (class of 1828), seven years of service as a regular Army officer, and colonel of the First Mississippi Rifles during the War with Mexico, where he was wounded at the Battle of Buena Vista. During the 1850s, he was the most knowledgeable and innovative secretary of war who had ever served. Secretary Davis overcame cost concerns to organize a cavalry regiment to combat the horseback warriors of Texas. (A cavalry regiment cost $1.5 million annually, as opposed to just $300,000 for a regiment of infantry.) The US Camel Corps was created to utilize desert beasts as pack animals in the arid Southwest, and rifles replaced muskets among infantry units. (Courtesy of the National Archives and Records Administration.)

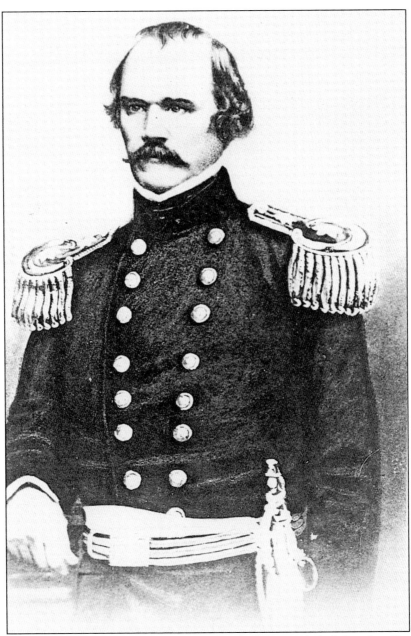

Albert Sidney Johnston was appointed first colonel of the crack 2nd Cavalry. His military background was extensive: West Point (class of 1826), two substantial tours of duty as an officer with the US Army, brigadier general of the Texas Army, secretary of war of the Republic of Texas, and colonel of a Texas regiment during the War with Mexico. The 2nd Cavalry was enlisted and organized at Jefferson Barracks, on the Mississippi River just south of St. Louis. Astride his magnificent mount Grey Eagle, Colonel Johnston led his new regiment out of Jefferson Barracks on October 27, 1855. The column arrived on the Texas frontier in January 1856 with 37 officers and 608 enlisted men. Colonel Johnston and six troops established regimental headquarters at Fort Mason, while the other six companies were stationed at smaller outposts. (Courtesy of the National Archives and Records Administration.)

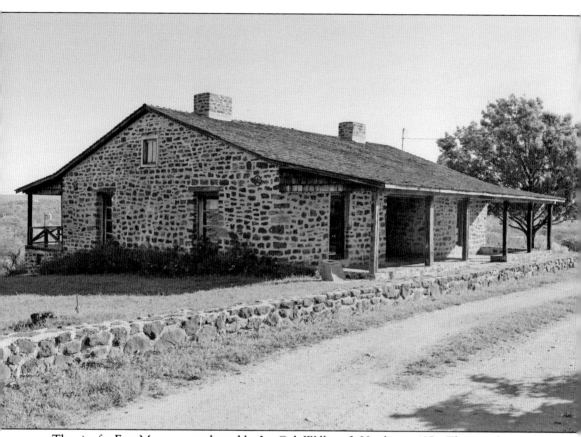

The site for Fort Mason was selected by Lt. Col. William J. Hardee in 1851. The parade ground was laid out atop Post Oak Hill, with two creeks nearby. A settlement soon began to develop at the foot of the hill, and Mason would become the seat of Mason County. For 10 years, soldiers from Fort Mason campaigned aggressively against area Comanches, Kiowas, and Lipan Apaches. In 1856, Fort Mason became regimental headquarters for the newly organized 2nd Cavalry. Col. Albert Sidney Johnston arrived, along with the headquarters company, regimental band, and six combat troops. Following the Civil War, Fort Mason was reoccupied from 1866 until 1869. After the Army left, civilians helped themselves to building materials, but the commanding officer's quarters shown above was rebuilt on the original foundation. (Author's collection.)

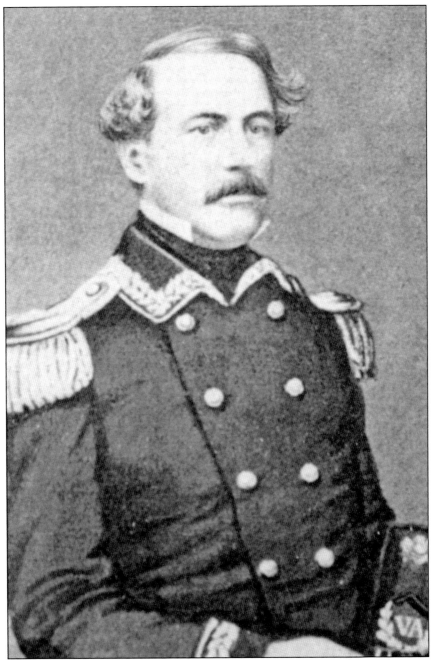

Robert E. Lee was appointed lieutenant colonel of the 2nd Cavalry. Lee had compiled a superlative record at West Point (class of 1829), he was a standout combat officer during the War with Mexico, and he served as superintendent of West Point from 1852 until 1855. From 1855 through 1857, Lee was assigned to six court-martial tours, which took him to a number of Texas forts. While in Texas, his main duty posts were at Fort Mason, Camp Cooper, and department headquarters in San Antonio. Twice, Lee commanded the 2nd Cavalry during the absence of Colonel Johnston, and after Lee returned to Texas in 1860 following an extended leave, he was promoted to colonel of the regiment. (Courtesy of the National Archives and Records Administration.)

When the 2nd Cavalry marched into Texas, prominent among its new equipment was the latest development in sidearms. During the 1840s, Texas Rangers battling Comanche warriors utilized early Colt five-shooters to counter bows and arrows. Each side thus had repeating weapons that could be fired from horseback. Revolving pistols evolved rapidly, and by the 1850s, the .36 Navy model Colt was the best cap-and-ball revolver available. (Author's collection.)

In 1858, Remington introduced its .44 Army model, which offered the plow-grip handles and loader (beneath the barrel) that had become standard features. A backstrap stabilized the weapon and provided a larger back sight. The detachable cylinder greatly facilitated reloading. Many officers and men of the 2nd Cavalry fought in the Civil War, and the two most popular handguns were the .36 Navy Colt and the .44 Army Remington. (Author's collection.)

John Bell Hood was an 1853 graduate of West Point, when the superintendent was Robert E. Lee. In 1855, Second Lieutenant Hood was assigned to Company G of the elite 2nd Cavalry. Operating out of Fort Mason in July 1857, Hood and 17 troopers were attacked by almost 100 warriors near the headwaters of Devil's River. Hood's left flank was struck by a mounted party, while warriors on foot suddenly emerged from concealment and rushed in from the other side. But Hood directed coordinated revolver fire from his men, and the charge was broken. Hood himself carried two revolvers and a double-barreled shotgun. When his left hand was pinned to his saddle by an arrow, he broke off the shaft and jerked his hand free. The warriors withdrew with 19 dead and as many wounded, while two cavalrymen were killed and four seriously injured. (Courtesy of the National Archives and Records Administration.)

As Texas settlers moved west, a new line of frontier forts was needed. Gen. William G. Belknap established the northernmost post in the new line, located at today's town of Newcastle. But not even a 66-foot well could produce adequate water, so Fort Belknap was moved two miles south. The new site featured stone buildings, including a solid powder magazine. (Author's collection.)

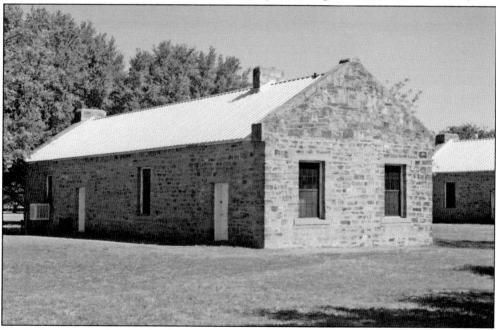

Fort Belknap boasted six 80-foot-long stone barracks in a row, and the two easternmost company quarters have been reconstructed on the original foundations. Serving at Fort Belknap were elements of the 5th and 7th Infantry Regiments, the 2nd Dragoons, and the 6th Cavalry. In 1855, the elite 2nd Cavalry marched through Fort Belknap on its way into Texas. (Author's collection.)

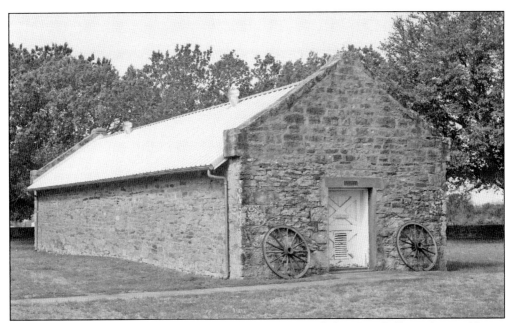

In 1854, the Texas State Legislature set aside 70,000 acres below Fort Belknap for two Native American reservations. The Wacos, Anadarkos, and other semi-agricultural tribes settled on these reservations, and the cornhouse at the fort was used to store rations. But troublemaking white settlers coveted the designated lands, and the reservations were discontinued in 1859. Troops from Fort Belknap escorted the Native Americans north into Indian Territory. (Author's collection.)

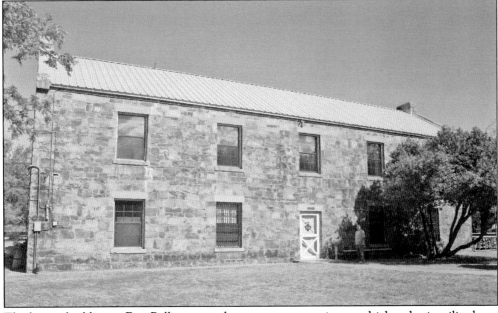

The largest building at Fort Belknap was the two-story commissary, which today is utilized as a museum. The fort was abandoned at the outbreak of the Civil War, although the site was sometimes used by the Texas Home Guard. Although reconstruction began in 1867, the establishment of two new nearby forts, Griffin and Richardson, decreed the final abandonment of Fort Belknap. (Author's collection.)

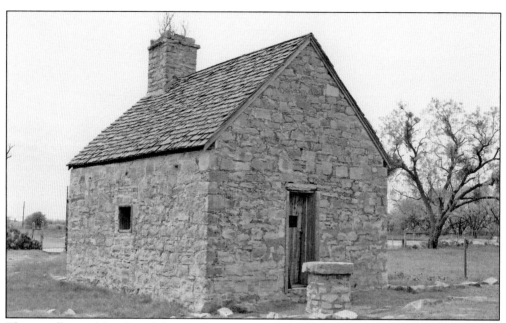

The guardhouse (above) and the powder magazine (below) were the only two buildings at Fort Phantom Hill constructed completely of stone. The Post on the Clear Fork of the Brazos—Fort Phantom Hill was an unofficial designation—was established in November 1851 to guard a major trail to California. But the water supply was uncertain, and building materials were scarce. Five companies of the 5th Infantry—half of the regiment—settled into tents and began construction work on more permanent quarters. In charge of these efforts was the regimental commander and first commandant of the post, Col. John J. Abercrombie. Although game abounded in this isolated area, water often had to be hauled from a spring four miles away. (Both, author's collection.)

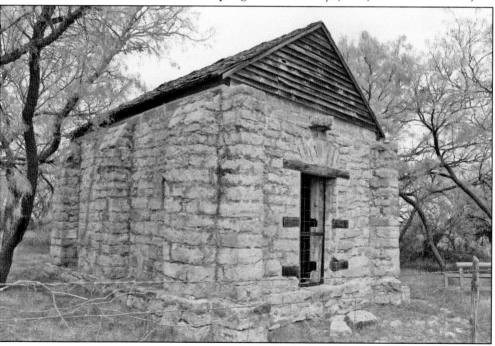

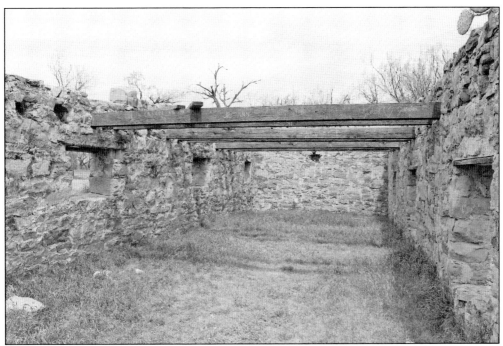

The lower level of the two-story commissary was built of stone, with a second story of logs and a thatched roof. A stone quarry was opened just two miles from the fort, but logs had to be hauled by ox-drawn wagons from a distance of 40 miles. Officers' quarters and the three-room hospital were built of squared logs, but all other buildings were of picket or jacal construction. All structures had thatched roofs and stone chimneys. (Author's collection.)

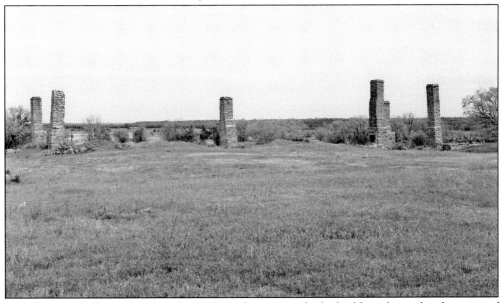

Fort Phantom Hill was abandoned in 1854, and mysteriously the buildings burned within view of the departing troopers. The stone chimneys remained and travelers camped amid the remaining structures of the old fort. In 1858, the repaired site became a Butterfield Stagecoach stop. Occasionally, military details used the post as a campsite, and so did cowboys. (Author's collection.)

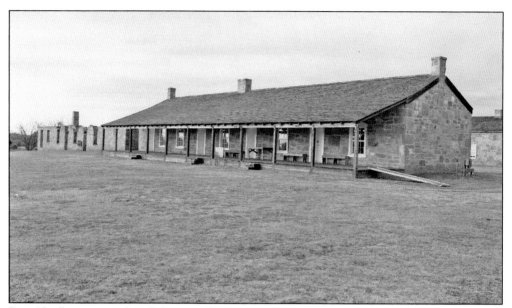

Fort Chadbourne was founded in 1852 by two companies of the 8th Infantry. Established beside Oak Creek, Fort Chadbourne was intended to be a two-company post. Stone was abundant and quarried nearby to provide the principal building material. On the north side of the parade ground, two company barracks were built, each 100 feet long and 20 feet wide. (Author's collection.)

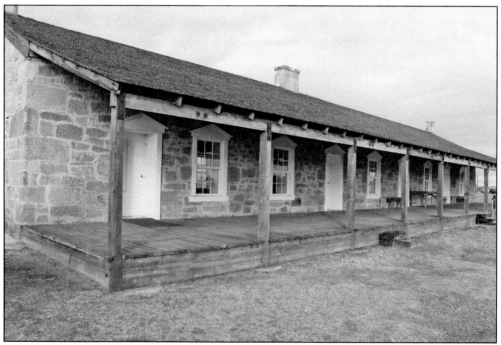

The east barracks has been restored. It was originally constructed by a civilian carpenter and a civilian stonemason, with day labor performed by soldiers. Soldiers who did not work on the buildings served as teamsters, hauling in building materials such as doors, windows, shingles, and planed lumber. Behind each barrack was a mess hall built of posts and canvas. (Author's collection.)

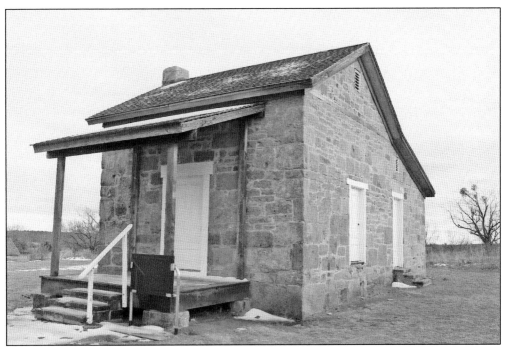

There were two or three officers' quarters built of stone and at least three more constructed of posts and canvas. Officers who served at Fort Chadbourne included such future Civil War luminaries as Lt. John B. Hood, Lt. James Longstreet, Capt. Earl Van Dorn, and Lt. Miles Keogh, who died with Custer in 1876. Rev. Tobias Michell served nearly five years as post chaplain, the longest tenure of any man stationed at Fort Chadbourne. (Author's collection.)

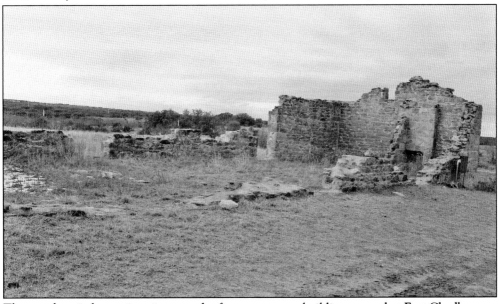

The post hospital, now in ruins, was the first permanent building erected at Fort Chadbourne. At first the hospital was 60 feet long, but later it was expanded to 100 feet. A physician, usually designated an assistant surgeon, almost always was stationed at Fort Chadbourne during its existence (1852–1861 and 1867–1868). (Author's collection.)

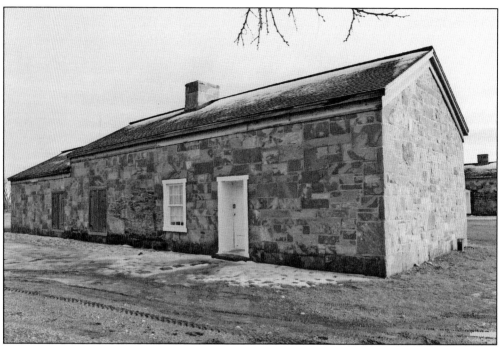

In 1858, when the Butterfield Stagecoach Line established an overland mail route to California, a stone stage station was erected just behind the barracks at Fort Chadbourne. The building housed Butterfield employees, as well as a dining hall and a stable on the east end. It is the only restored Butterfield Stagecoach station in Texas. (Author's collection.)

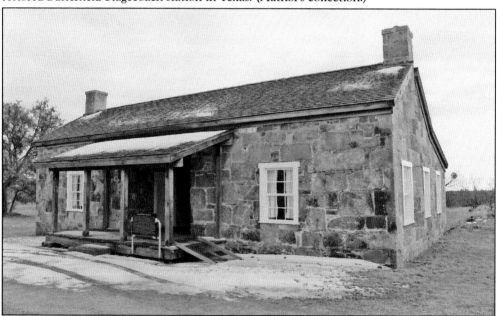

This stone structure probably served as a residence in the commanding officer's quarters. A few years after the fort was abandoned in 1868, Thomas Odom acquired the property as his ranch headquarters, raising his large family in this house while utilizing other buildings as stables, barns, and storage. (Author's collection.)

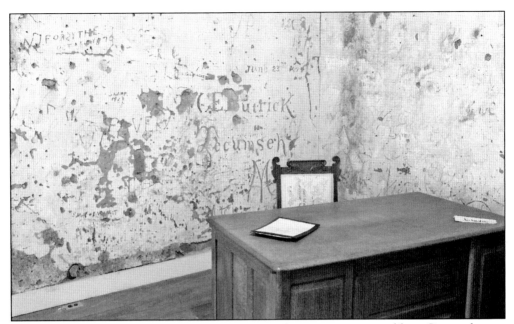

In 1856, two Fort Chadbourne troopers on courier duty were intercepted by a Comanche war party and tortured to death. A few weeks later, about 20 Comanches, male and female, came to the fort, and when it was discovered that the braves were carrying stolen guns and mail, soldiers opened fire. As half a dozen of his warriors fell, Chief Sanaco fought from behind this table in the commander officers' quarters until he was killed. (Author's collection.)

This root cellar was behind the commander officers' quarters. A large vegetable garden was tended by soldiers not far from the post. Across Oak Creek was a hog ranch called Scab Town. In later years, the old root cellar served the neighborhood as a post office. (Author's collection.)

Fort Lancaster began as a two-company post in 1855. The mission of the outpost was to safeguard the San Antonio to El Paso Road, and there were periodic clashes with war parties. The Camel Corps passed through Fort Lancaster, and by the late 1850s, three Butterfield Stagecoaches per month stopped off at the isolated post. (Author's collection.)

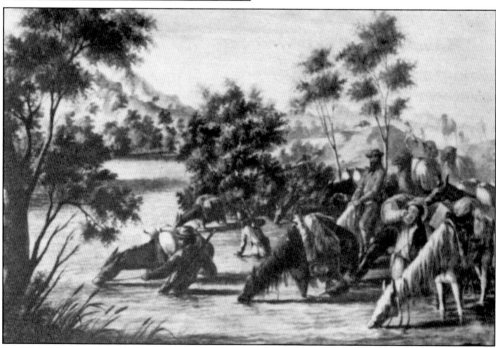

In 1855, Congress appropriated $30,000 for the War Department to purchase camels for use as pack animals in the arid Southwest. Secretary of War Jefferson Davis imported thirty-three camels to Texas that year, and in 1857, forty-one more arrived. Camels could travel long distances without water and ate virtually any plant, although they frightened horses and were ornery and smelly. (Courtesy Fort Lancaster State Historic Site.)

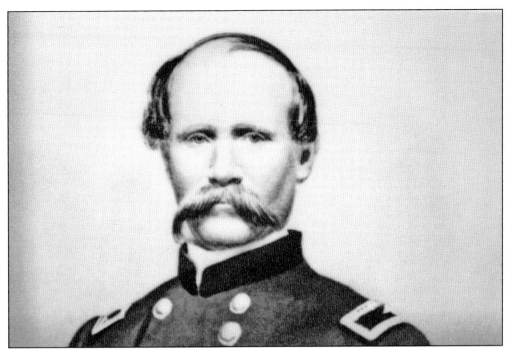

Twice during the early years of Fort Lancaster, the commanding officer was Capt. Robert S. Granger, who was brevetted to major general during the Civil War. Captain Granger lived with his family at the sprawling commander officers' quarters. The commander officers' quarters was built of stone and adobe and boasted a shingled roof. There were more than 25 other stone or adobe buildings at Fort Lancaster. (Courtesy Fort Lancaster State Historic Site.)

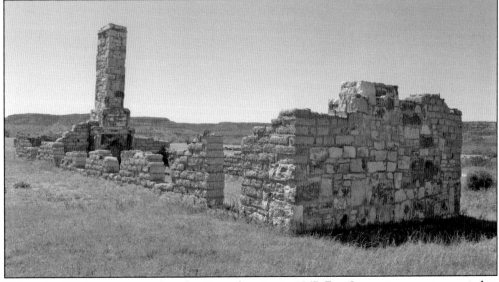

When the US Army returned to the Texas frontier in 1867, Fort Lancaster was reoccupied as a sub-post of Fort Stockton. Company K of the 9th Cavalry was stationed at Fort Lancaster, occupying the barracks that had been built a decade earlier. Although it stands in ruins today, when it housed cavalrymen, there were wooden floors and the stone walls were whitewashed and stuccoed. (Author's collection.)

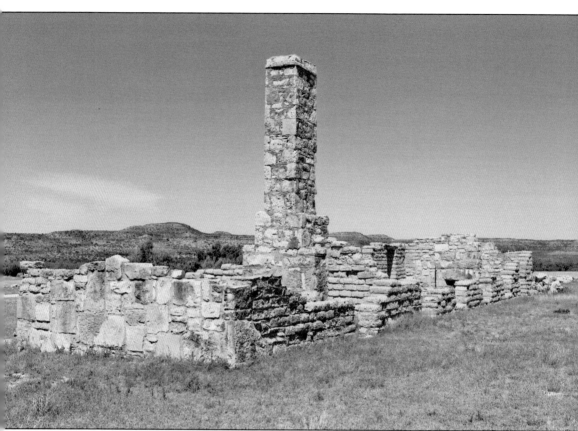

On the day after Christmas in 1867, a party leading cavalry horses to water was attacked by 400 Kickapoo warriors and their allies. A teamster was lassoed, dragged away, and murdered. Two troopers also were killed, but survivors of the watering party drove the herd back to the post. The garrison consisted only of an understrength Company K of the 9th Cavalry, and the warriors attacked the fort from the north, south, and west. But the officers formed their men into a semicircular skirmish line across the parade ground, and the 40 buffalo soldiers fought with courageous resolve. Armed with seven-shot Spencer repeating carbines, the troopers kept up a steady fire. The warriors soon withdrew, and Fort Lancaster became the only frontier post in Texas to survive a Native American assault. (Author's collection.)

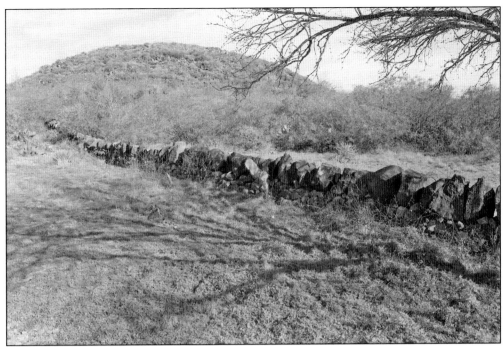

Fort Inge was founded in 1849 beside "Mount" Inge, a 150-foot rocky hill that stood next to a major Comanche war trail that raiders regularly followed into Mexico. Sentries manned the hilltop each day, scanning the war trail for miles in each direction. When war parties were sighted, mounted patrols promptly were sent in pursuit. (Author's collection.)

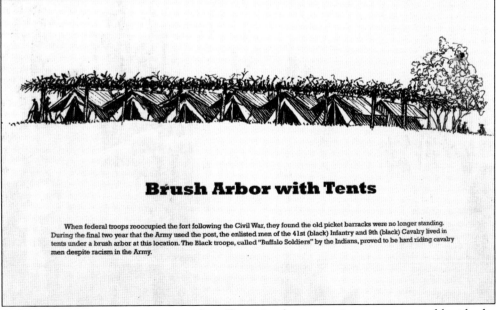

Brush Arbor with Tents

When federal troops reoccupied the fort following the Civil War, they found the old picket barracks were no longer standing. During the final two year that the Army used the post, the enlisted men of the 41st (black) Infantry and 9th (black) Cavalry lived in tents under a brush arbor at this location. The Black troops, called "Buffalo Soldiers" by the Indians, proved to be hard riding cavalry men despite racism in the Army.

A dozen structures—some no more than flimsy jacal construction—were erected beside the Leona River. A long row of tents for enlisted men was sheltered by a brush arbor. The largest building at Fort Inge was the limestone hospital. There was an office room and a big ward, and the foundation still exists. (Courtesy of Fort Inge Historical Park.)

William B. Hazen was an 1855 graduate of West Point who saw action against hostiles in Oregon and Arizona before being assigned to the 8th Infantry and Fort Inge. Riding out of Fort Inge, Hazen experienced frequent combat in 1859 and received three citations for bravery. On November 3, 1859, Hazen led a patrol in a charge against eight Comanche warriors who recently had slain two settlers. Hazen and three of his men were wounded, but seven braves were fatally wounded and only one injured warrior managed to escape. Hit in the side, Hazen's wound was critical, and he was furloughed for a year. During the Civil War, Hazen was a corps commander who was part of Sherman's famous march to the sea. In 1880, General Hazen became chief of the US Army Signal Corps, but in 1887, when he was 56, he died from complications from the Comanche bullet he caught in Texas. (Courtesy of the National Archives and Records Administration.)

Three

THE BORDER FORTS

In addition to providing protection for the western frontier of Texas, the US Army also had to police the long border with Mexico, defined by the Rio Grande. The first US Army presence on the Rio Grande came in 1846 when Gen. Zachary Taylor led a large force to establish the river as the boundary of the new state of Texas. There was challenge from Mexican soldados on the opposite side of the Rio Grande, and hostilities erupted. The ensuing War with Mexico (1846–1848) saw Taylor's original encampment, now called Fort Brown, utilized as a major staging base.

Following the war, the Rio Grande constantly was plagued by Mexican raiders, smugglers, revolutionaries, and war parties. Fort Brown, near the mouth of the Rio Grande, became a permanent outpost, and in 1848, a string of other military posts was established. Fort Ringgold, Fort Duncan, and Fort McIntosh were busy throughout the 1850s protecting settlements from rustlers and Comanches and bandidos. The best-known adversary of the US Army was the legendary Juan Cortina, who battled US troops and Texas Rangers from the vicinity of Fort Brown as far upriver as Fort Ringgold. There were temporary encampments along the river, as well as Fort Quitman, far to the northwest, but no traces remain of these outposts. Even farther upriver was Fort Bliss at El Paso del Norte, established in 1848 and destined to become one of the nation's largest and most important military bases.

During the Civil War, the border forts were occupied by Confederate troops. But in 1867 and 1868, these posts were re-garrisoned by the US Army, with substantial new construction at each site. Although the Indian Wars ended during the 1880s, rustlers and smugglers remained active along the Rio Grande, and while frontier forts closed in the interior of Texas, border posts remained garrisoned. In the second decade of the 20th century, revolution in Mexico triggered renewed activity in the border forts, and such military activities continued during World Wars I and II. At the end of World War II, however, the border forts were closed—with the important exception of Fort Bliss. Today, the remaining structures of Forts Brown, Ringgold, Duncan, and McIntosh are utilized by schools and city parks.

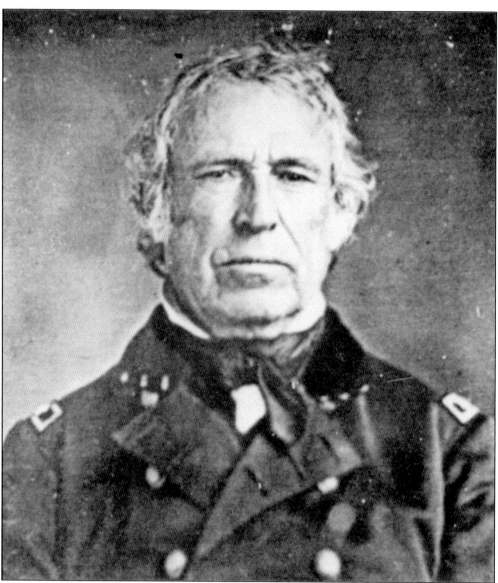

In March 1846, Gen. Zachary Taylor and a large force of the US Army arrived near the mouth of the Rio Grande opposite Matamoros. Taylor's purpose was to establish the Rio Grande as the southern boundary of Texas, which recently had become the 28th state in the Union. Accordingly, a large earthwork named Fort Texas was built on the north side of the Rio Grande. Mexican troops were present to challenge US authority, and during an ensuing bombardment, Maj. Jacob Brown was killed. Major Brown was buried within the fortification, which was renamed Fort Brown. For the next two years, Fort Brown was a military tent city, and at the end of the War with Mexico, a permanent post was built a few hundred yards north of the earthen fort. (Courtesy of the National Archives and Records Administration.)

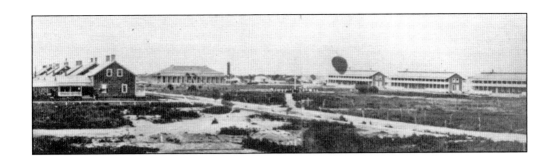

The community of Brownsville grew up beside the fort, and a brick wall—called the quartermaster's fence—was built to separate the fort from the town. In 1860, during the Cortina War, Col. Robert E. Lee was stationed at Fort Brown. The Civil War brought Confederate as well as Union troops, and the buildings of Fort Brown were burned. The final battle of the Civil War—won by Confederate States of America forces—was fought in the vicinity of Fort Brown. Beginning in 1869, Fort Brown was substantially rebuilt (above). The brick hospital (below) became a college building when Fort Brown was deactivated at the end of World War II. (Both, author's collection.)

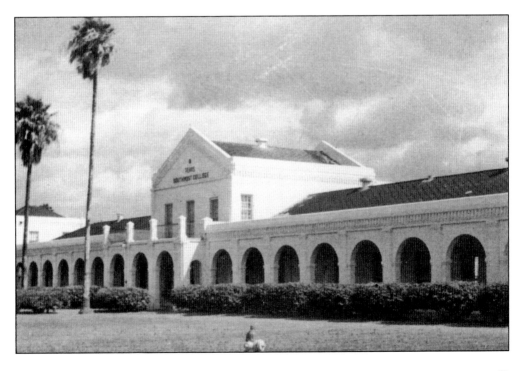

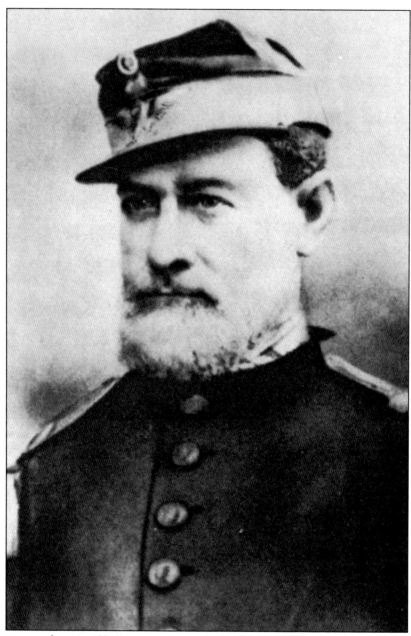

Juan Cortina was born in 1824 into an aristocratic family who held lands on both sides of the Rio Grande. Born to a leadership role, Cortina found himself and fellow Tejanos reduced to secondary status by norteamericanos who came to control Texas. During the War with Mexico, Cortina campaigned with the Mexican army. Afterward, he championed Tejanos who were victimized by norteamericanos, and in 1859, he wounded the city marshal of Brownsville who was abusing a Tejano prisoner. Collecting an army that grew to more than 500, Cortina battled the US Army and Texas Rangers, facing off against noted Ranger captains John S. "Rip" Ford and Leander McNelly, along with Col. Robert E. Lee, commander of the military district. Cortina became a folk hero known as "Cheno" and the "Rio Grande Robin Hood," and Fort Brown was reoccupied to counter Cheno and his men. (Courtesy of the National Archives and Records Administration.)

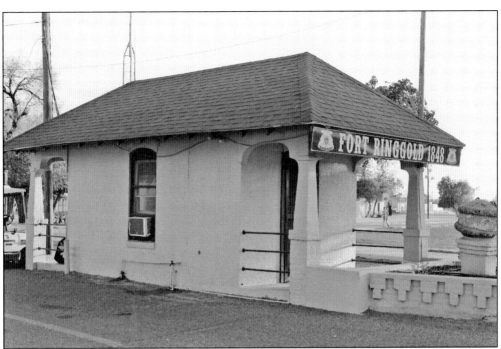

The federal outpost at Rio Grande City bore the name of Maj. Samuel Ringgold, who was fatally wounded at the Battle of Palo Alto in 1846. Established in 1848, Camp Ringgold—later Ringgold Barracks and Fort Ringgold—guarded the Rio Grande from border raiders, revolutionaries, and smugglers for nearly a century. Major periods of occupation were 1848 until 1861, 1865 until 1906, and 1917 until 1944. Permanent construction began in 1878 and included a substantial hospital. (Author's collection.)

Pressured by the Army and by Capt. John S. "Rip" Ford and his Texas Rangers, Cheno Cortina was forced upriver. A battle erupted near Ringgold Barracks, with Cortina losing 66 men. The combined Army-Ranger force of 380 men suffered 17 casualties while driving Cortina across the Rio Grande into Mexico. "You damned s.o.b.'s," shouted Ford (pictured), "we have got you." (Author's collection.)

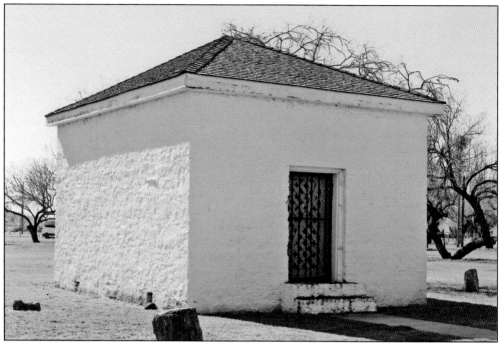

Fort Duncan was founded in 1849 near the Rio Grande village of Eagle Pass. Three companies of the 1st Infantry established the post. During the 1850s, the fort served as regimental headquarters of the 1st Infantry, and at times, troops of the First Artillery and of the Mounted Riflemen also served here. Eagle Pass was a busy trade crossing, and it was located on the California Road. There also were road connections to Fort McIntosh and Fort Inge. Stone was readily available as a building material, and one of two powder magazines is shown above. Below is a commissary building. (Both, author's collection.)

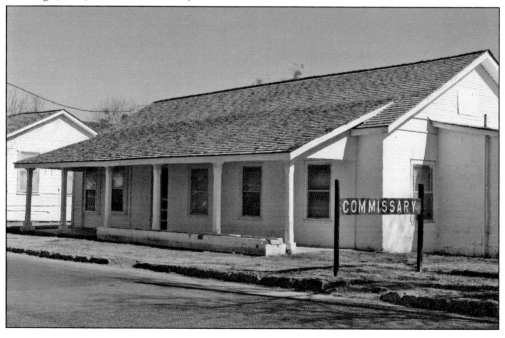

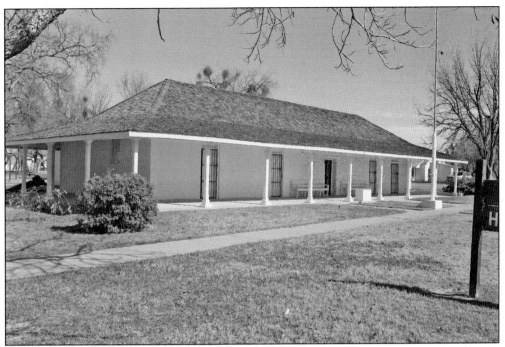

During the Civil War, elements of the Texas Frontier Regiment operated the post as Rio Grande Station. Rio Grande Station was ideally situated as a customs point for Southern cotton and for the munitions trade through Mexico. In 1868, the US Army reoccupied the post. Late in the 19th century, Fort Duncan was operated only as a sub-post of Fort Clark, but World War I brought a revival. At times, as many as 16,000 recruits trained at Fort Duncan. In the 1930s, the City of Eagle Pass acquired the base as Fort Duncan Park. The old post headquarters, above, became the Fort Duncan Museum. The building below was the commanding officer's quarters. During World War II, the military returned to train at Eagle Pass Air Field, but the facility soon reverted to park status. (Both, author's collection.)

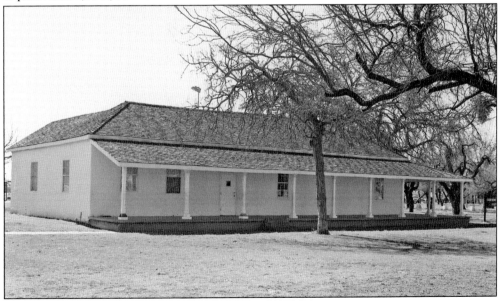

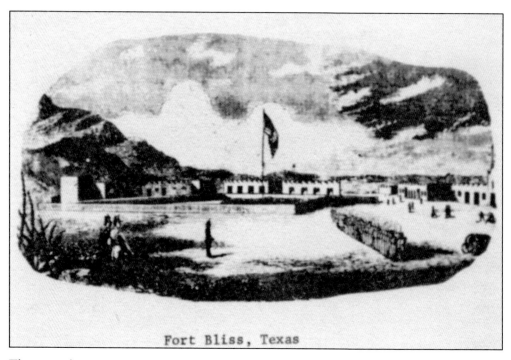

Fort Bliss, Texas

The original garrison at El Paso del Norte occupied Coons' Rancho (now downtown El Paso), but in 1851, the troops were transferred into New Mexico. In 1854, Secretary of War Jefferson Davis ordered the reestablishment of the post under the name Fort Bliss, in memory of Lt. Col. W.W. Bliss, chief of staff of Gen. Zachary Taylor during the War with Mexico. The garrison rented quarters at Magoffinsville, three miles from Coons' Rancho, until 1867, when a Rio Grande flood swept away everything at the post. Three miles to the north, the garrison established an encampment just below Concordia Cemetery. In 1878, the post moved to downtown El Paso, dubbed Garrison Town by the troopers. The following year, there was another move, three miles westward to Hart's Mill. (Both, courtesy of the National Archives and Records Administration.)

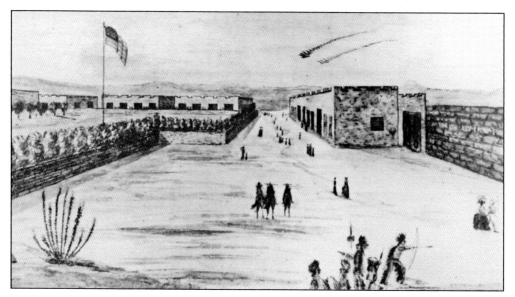

Fort Bliss has been a major military base for more than a century. Today, commanding an area of 1,700 square miles, Fort Bliss is the US Army's second-largest base (behind only the nearby White Sands Missile Range). But the founding decades of this frontier outpost were marked by a series of relocations in search of a permanent site. In 1948, on the centennial of the fort's founding, a replica of the original adobe buildings was erected. (Courtesy of the National Archives and Records Administration.)

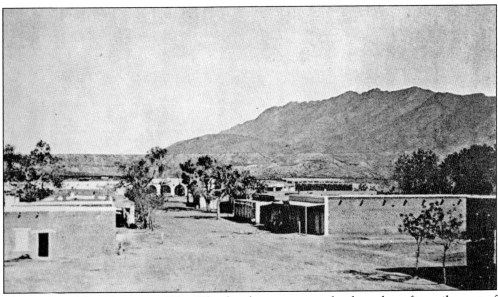

The sixth and final location of Fort Bliss headquarters was a land purchase five miles east of downtown El Paso. Community leaders raised $7,000 toward the acquisition of property for a permanent post, and Congress appropriated $300,000 for construction. Late in 1893, the garrison moved into Fort Bliss. (Courtesy of the National Archives and Records Administration.)

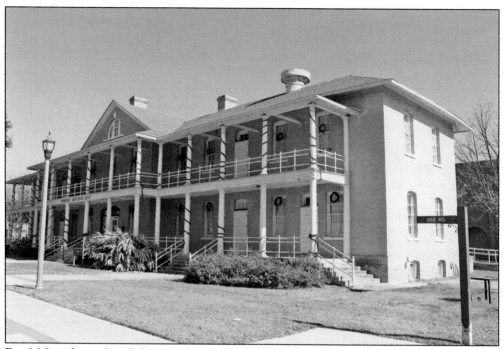

Fort McIntosh was founded at Laredo in 1849. Laredo was the Rio Grande crossing of El Camino Real—the long Spanish road that stretched from Mexico City to Florida. A Spanish presidio had been built to protect this crossing. In 1849, the US Army set up a tent encampment just west of Laredo. Utilizing Army engineers and the labor of enlisted men, a star-shaped earthwork was erected overlooking the Rio Grande crossing of a major Comanche war trail. During the Civil War, Confederates occupied the fort and withstood federal assaults. After the Civil War, Union forces returned to Fort McIntosh and soon began to build permanent structures. The post hospital (above) and an impressive set of officers' quarters (below) were erected in 1885. The military moved out in 1946, and these and other structures became part of Laredo Junior College. (Both, author's collection.)

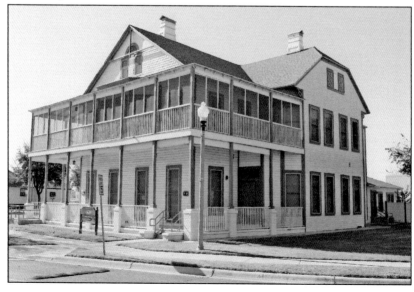

Four

NEW FORTS IN WEST TEXAS

After the outbreak of the Civil War early in 1861, frontier forts of Texas were abandoned with the departure of the US Army. During the war, some of the old outposts sporadically were used as patrol and pursuit bases by the Frontier Regiment, created in November 1861 by the Texas Legislature. But the Frontier Regiment was spread thinly across the vast Texas frontier. Comanche raids increased steadily, especially after the Frontier Regiment was incorporated into the manpower-starved Confederate army late in 1863. Small militia companies, providing their own weapons, horses, and provisions, proved ineffective as ranches were abandoned and the frontier was pushed back as much as 100 miles.

The raids continued beyond the war years. Even after the Confederate surrender in 1865, the US Army did not re-garrison the Texas frontier. During the first two years of Reconstruction, federal troops served as an occupation army in the settled portions of Texas. Frontier Texas, therefore, continued to be ravaged. From 1865 until July 1867, at least 163 Texans were slain by warriors in the frontier counties. Another two dozen settlers were wounded, and 43 were taken captive. In addition, more than 3,000 horses were stolen as well as 30,000 head of cattle. (Comanchero traders sought out Comanches, exchanging repeating rifles for cattle.)

In 1867, the federal government finally responded. The Army returned to the frontier, upgrading and re-garrisoning many of the older forts and establishing three new outposts.

Fort Concho was established in 1867, eventually boasting 40 limestone structures. Commanding officers of Fort Concho included Ranald Mackenzie, Benjamin Grierson, William R. Shafter, and Wesley Merritt. Units from Fort Concho fought in skirmishes and campaigned with Mackenzie in 1872, the Red River War in 1874–1875, and the Victorio campaign of 1879–1880. For several months, more than 100 Indian women and children captured by Mackenzie were confined in a stone corral at the post. The town that grew beside Fort Concho became an important West Texas community, San Angelo.

Fort Richardson, founded early in 1868, soon became the most important post in Texas. William T. Sherman, commanding general of the Army, visited Fort Richardson in 1871. Col. Ranald S. Mackenzie served as commandant of the post, using it as a staging base for his campaigns. There were 55 structures on the post, and in 1872, there were 666 officers and men stationed at Fort Richardson—the largest garrison of any military establishment in the United States.

Fort Griffin was established in 1867 on a flat hilltop above the Clear Fork of the Brazos River. At the bottom of the hill, a wild buffalo hunters' community, also dubbed Fort Griffin, became the site of gambling halls, saloons, brothels, and brawls, with such denizens as Doc Holliday, Pat Garrett, Lottie Deno, Wyatt Earp, and Wes Hardin.

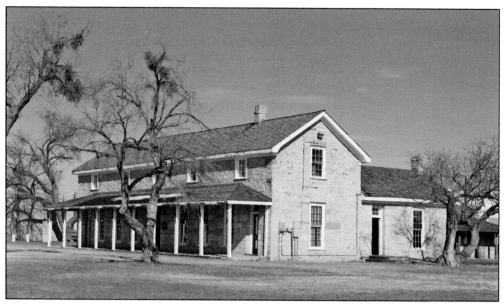

The two-story post headquarters at Fort Concho was built at the head of the parade ground by Col. Benjamin Grierson in 1876. Rooms on the first floor included an entry hall, the post adjutant's office, regimental administrative office, commander's office, clerk and orderly room, and, in the rear, a court-martial hall and the post library/reading room. In addition, there were four rooms upstairs. (Author's collection.)

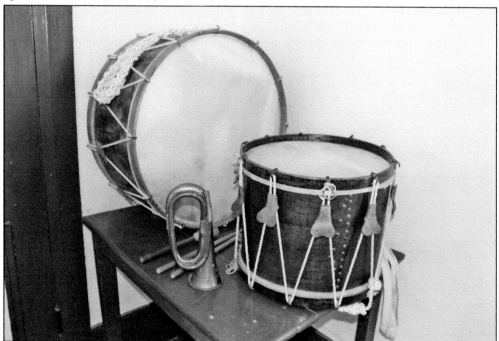

The drums and bugle are on display at the orderly room in the headquarters building. A bugler normally was on duty at the orderly room throughout the day. But if the bugler was in the field, a drummer could beat commands that could be heard across the parade ground, including "Reveille" each morning and "Tattoo" at night. (Author's collection.)

The court-martial room was in frequent use. Soldiers could be court-martialed for breaches of the Articles of War and for violation of garrison regulations. Charges ranged from murder to insubordination to unbuttoned blouses to missing roll call. The most prevalent military crime during the Indian War was desertion. About one-third of the enlistees during this era deserted, which added up to considerable loss of government property. Although few officers had legal training, they served as members of the court. Most garrison courts-martial were staffed by three officers, who served as judge and jury and who often were primarily concerned with enforcing discipline. Indeed, 32 of the 34 Articles of War left punishment to the judgment of the court. An enlisted man served as court stenographer. (Author's collection.)

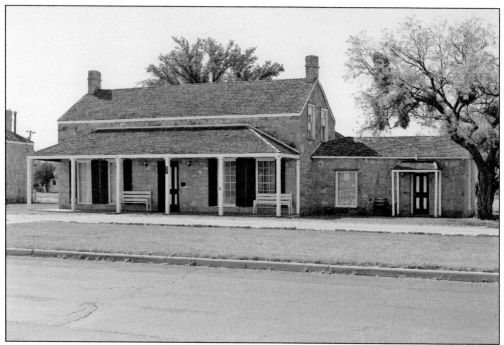

The commanding officer's quarters was the first residence erected on Officers' Row. Commanding officers at Fort Concho included Ranald Mackenzie, Benjamin Grierson, and William Shafter. (Author's collection.)

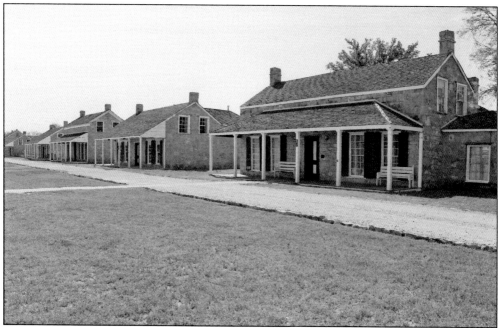

Only one of the nine residences along Officers' Row has been lost. After Fort Concho was deactivated in 1889, civilians acquired these houses and, through the years, altered the appearance of some of the buildings. For decades, the old Officers' Row was a prime residential street in San Angelo. (Author's collection.)

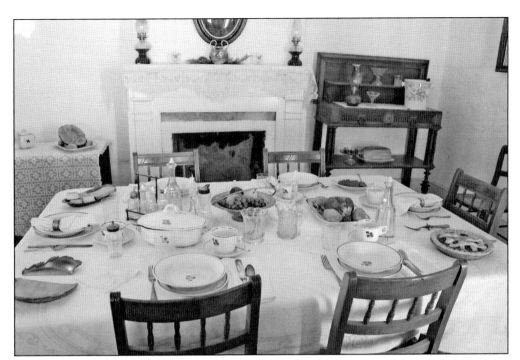

Prior to the completion of stone residences along Officers' Row, Fort Concho officers and their families made their homes in tents. (Courtesy of Fort Concho National Historic Landmark.)

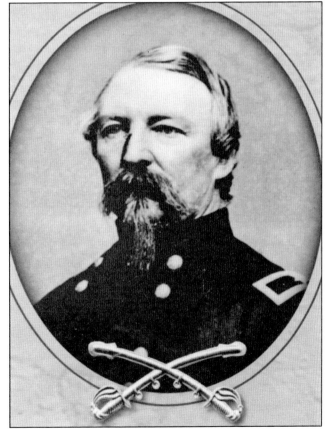

An 1845 graduate of West Point, John P. Hatch saw combat during the War with Mexico and during the Civil War earned a Medal of Honor and a brevet promotion to major general. In 1870, as a 4th Cavalry major in command at Fort Concho, his experiments with adobe construction gave Hatch the nickname "Dobe." (Courtesy of Fort Concho National Historic Landmark.)

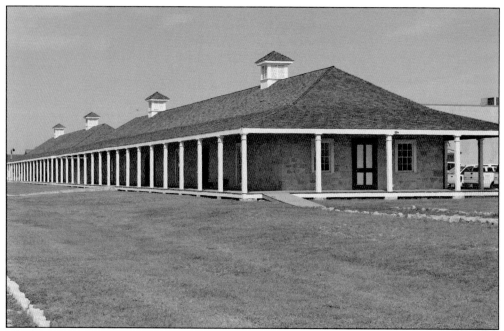

The first two company barracks were erected in 1868 and still stand side by side across the parade ground from Officers' Row. Two company buildings are gone from the middle of the barracks line, but two others of the original six still stand. As many as 400 officers and enlisted men sometimes were garrisoned at Fort Concho. (Author's collection.)

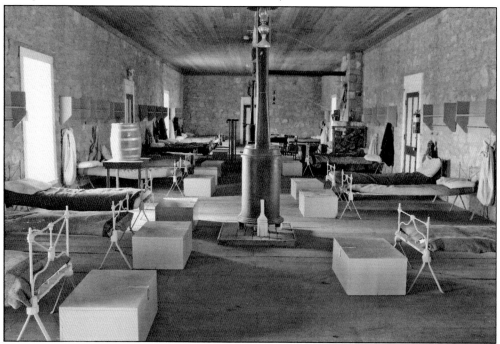

Half of each company barracks housed one of the troop's two platoons. This platoon room featured a large locker at the foot of each cot, along with a water barrel and a wood-burning stove. (Author's collection.)

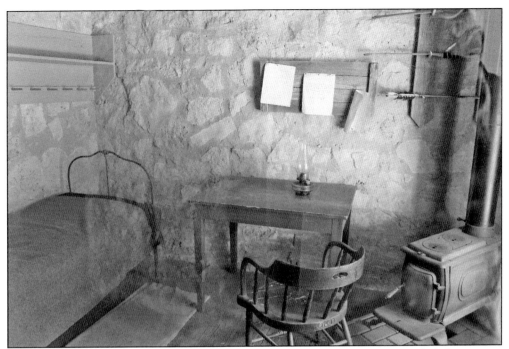

Each of the six sets of company quarters along the Fort Concho barracks line included a separate room for the troop's first sergeant. The first sergeant bunked in the room, and he conducted company business, which included numerous reports, from his desk. (Author's collection.)

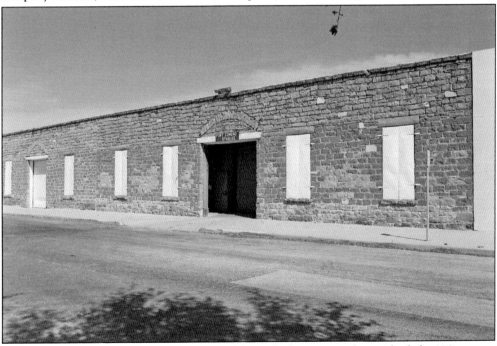

At a post as large as Fort Concho, cavalry stables and adjacent corrals were built for 400 or more horses. Farriers constantly worked at shoeing horses to keep them ready for field service, while saddlers labored in shops to repair saddles and tack damaged on patrols. (Author's collection.)

The post chapel stood opposite the hospital and doubled as a schoolhouse. (Author's collection.)

Most of the pupils at the post school were officers' children. During one period, the schoolmaster was a soldier who had education, but when the regiment was called into the field, his students enjoyed an unexpected vacation. (Author's collection.)

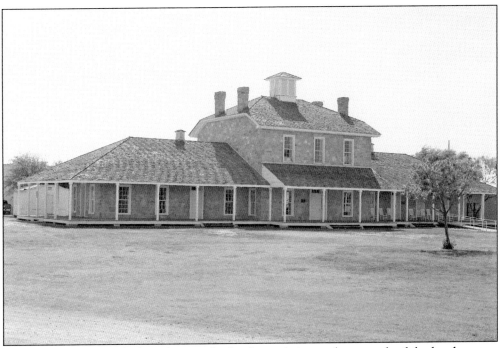

The post hospital was built with a standard military design and was south of the headquarters building. (Author's collection.)

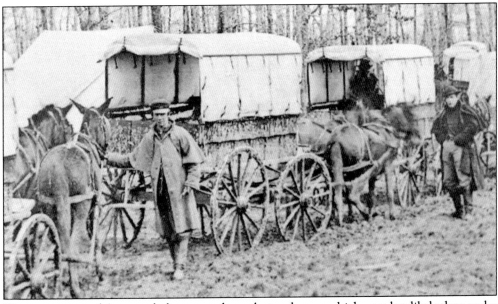

The canvas-topped Army ambulance was drawn by two horses, which were less likely than mules to bolt. In the field, the crew was a driver and two stretcher-bearers (privates). Ambulances frequently were arranged for passengers, usually officers' families. But on medical duty, the seats were rearranged to create a platform that could support two stretcher patients, with two more beneath, on the wagon bed. (Courtesy of Fort Concho National Historic Landmark.)

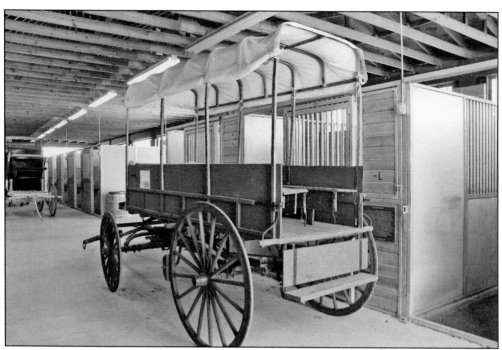

A restored ambulance is on display inside the Fort Concho stables, along with other historic vehicles. (Author's collection.)

The quartermaster storehouse stood next to headquarters (out of sight to the right), while the commissary was at left. The commissary at each post was the storehouse for provisions and rations, while the quartermaster warehouse stored equipment, clothing, bedding, tents, saddles, tack, and most other supplies aside from food. (Author's collection.)

In 1992, Fort Concho honored five Medal of Honor recipients who served at the post and who earned recognition for action in Texas in 1872 or 1874. The burial sites of these soldiers are unknown, so permission was obtained to place period military gravestones, along with a large interpretive marker, beside the quartermaster storehouse for Sgt. Edward Branagan, Cpl. William McCabe, and Pvts. Gregory Mahoney, William O'Neill, and John O'Sullivan. (Author's collection.)

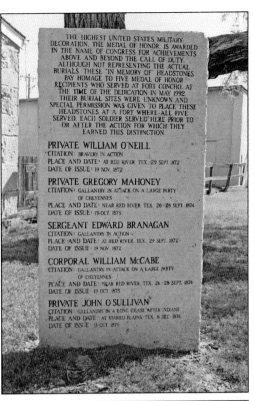

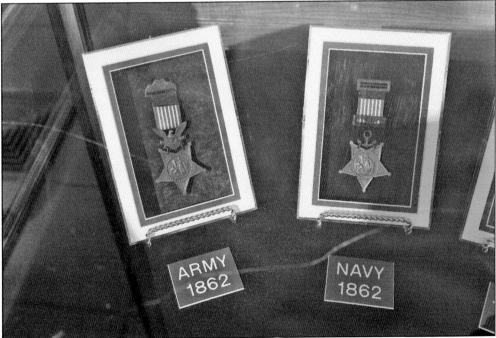

The Army Medal of Honor was authorized in 1862, while the Civil War raged. During the Indian Wars, 416 Medals of Honor were awarded for notable service, and in Texas, 61 men received medals for valor. (Author's collection.)

Robert G. Carter won the Medal of Honor in 1871 for turning a major Comanche charge at Blanco Canyon with five troopers triggering Spencer carbines rapid-fire. During the Civil War, young Carter lied about his age to enlist in the Union army. Following heavy combat, Carter earned a commission at West Point. He became the right-hand man of Ranald Mackenzie, who credited Carter for saving his command at Blanco Canyon. (Courtesy of the National Archives and Records Administration.)

The powder magazine originally stood much farther north as a safety precaution, but it has been moved close to the parade ground and the museum area. (Author's collection.)

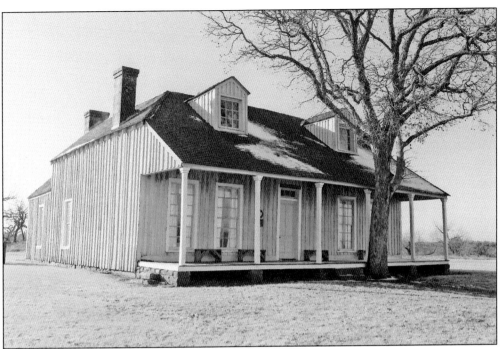

Officers' Row at Fort Richardson consisted of five one-and-a-half-story frame residences, each with a spacious front gallery (porch) and eight rooms, and five plain picket houses. The only remaining frame house was the commanding officer's quarters, which was inhabited for a time by Col. Ranald Mackenzie. Mackenzie, a bachelor, was considerate enough to share the big commanding officer's quarters with a married officer and his family. (Author's collection.)

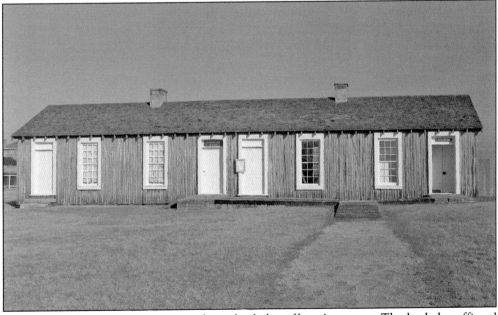

This simple picket structure was used as a bachelor officers' quarters. The bachelor officers' quarters usually housed several junior officers. Today, the building is utilized as a museum for the Fort Richardson Historic Site. (Author's collection.)

Ranald S. Mackenzie was a "boy general" of the Civil War who became known as the finest regimental commander of the Indian Wars. After graduating first in his West Point class of 1862, Mackenzie distinguished himself during Civil War combat, receiving numerous wounds, decorations, and promotions. Two fingers of his right hand were shot off, which led western Native Americans to call him "Bad Hand" and "Three Fingers." Brevetted to the rank of major general, he was termed "the most promising young officer in the army" by General Grant. Placed in command of the 4th Cavalry in 1870, Colonel Mackenzie whipped it into a crack regiment. Mackenzie campaigned in Texas from 1871 to 1875, leading the 4th Cavalry in a series of actions that were instrumental in driving Native Americans from West Texas. (Courtesy of the National Archives and Records Administration.)

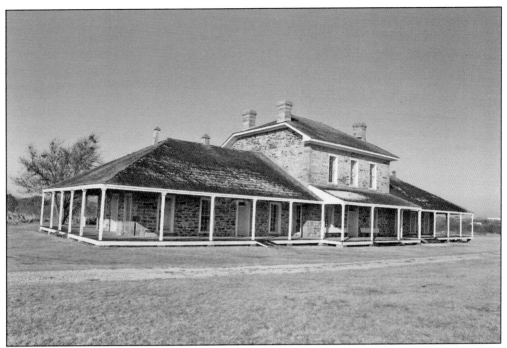

The big post hospital dominated the west side of the parade ground. The two-story center of the hospital included administrative offices, surgery room, medicine storage, dining hall, and kitchen. The central section was flanked by two 12-bed wards. (Author's collection.)

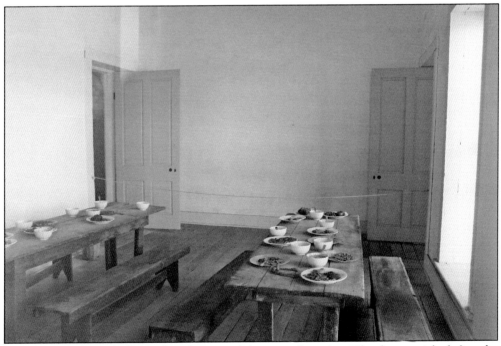

The hospital dining hall stood at the rear of the central section. The door at right led to the kitchen. (Author's collection.)

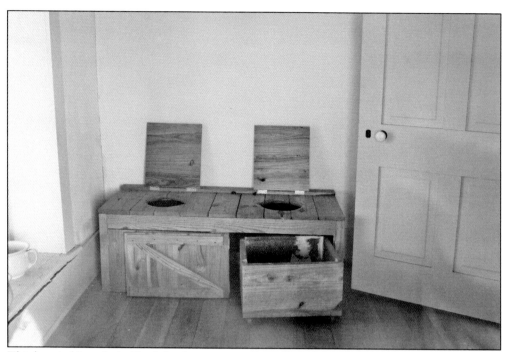

This hospital "two-holer" had the distinction and comfort of an indoor location. Almost all toilet facilities at frontier outposts were outhouses or "sinks." (Author's collection.)

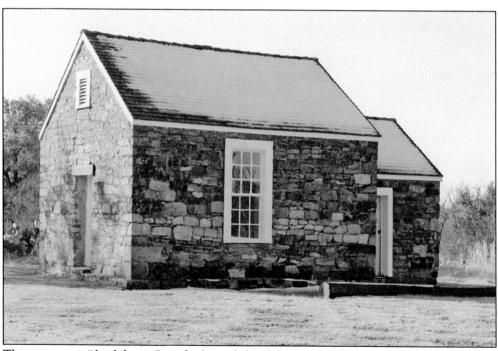

This morgue, or "death house," was built just behind the hospital. The presence of a morgue was common on the Texas frontier, where withering heat ripened corpses before a grave could be opened in ground so rocky that dynamite sometimes had to be used. (Author's collection.)

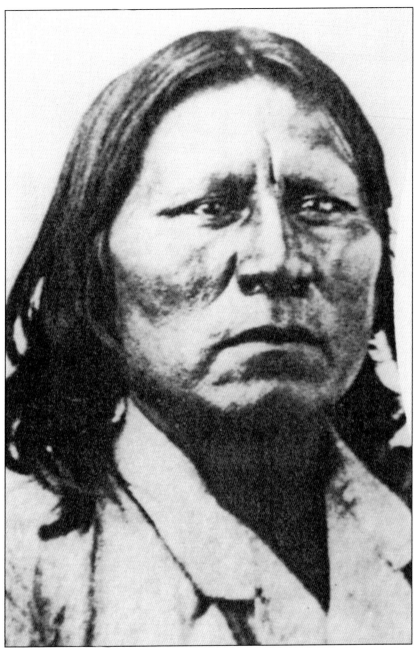

Satanta (which translates to "white bear") was the principal chief of the Kiowas. By the time Satanta was 40, around 1870, he was living with most of his people on the Kiowa Reservation in western Oklahoma. But he continued to lead raids into Texas. On May 17, 1871, Satanta and other chiefs led more than 100 warriors against a supply train about 20 miles from Fort Richardson. Seven teamsters were killed and 41 mules were driven off in the Warren Wagon Train Raid. Soon, however, Satanta and two other leaders were arrested at Fort Sill. En route to Fort Richardson, one chief was killed trying to escape. Satanta and Big Tree were sentenced to hang. Paroled by Gov. E.J. Davis, Satanta later was rearrested and returned to the penitentiary, where he committed suicide in 1878. (Courtesy of Fort Richardson Historical Museum.)

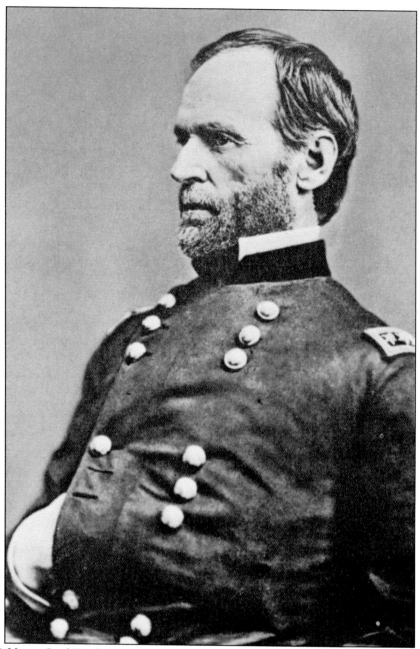

In 1869, Union Civil War hero William T. Sherman was promoted to commanding general of the Army. Responding to complaints of Comanche and Kiowa raids, General Sherman came to Texas for a personal inspection tour. In May 1871, he departed San Antonio with a 17-man escort of the 10th Cavalry. Proceeding to Forts Mason, McKavett, Concho, Griffin, and Belknap, General Sherman concluded that there was little threat beyond occasional horse theft. Riding from Fort Belknap to Fort Richardson on May 16, Sherman's little detail passed by more than 100 concealed warriors led by Chiefs Satanta, Satank, and Big Tree. The next day, this war party devastated a teamster train. Sherman abruptly ordered Col. Ranald Mackenzie, in command at Richardson, to launch pursuit. (Courtesy of the National Archives and Records Administration.)

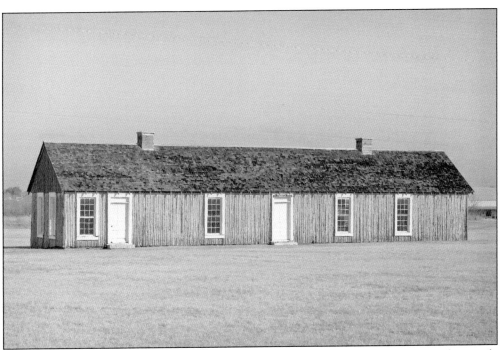
This company barracks stood in a line with other barracks facing Officers' Row across the parade ground. Cavalry stables and corrals were placed behind the barracks. (Author's collection.)

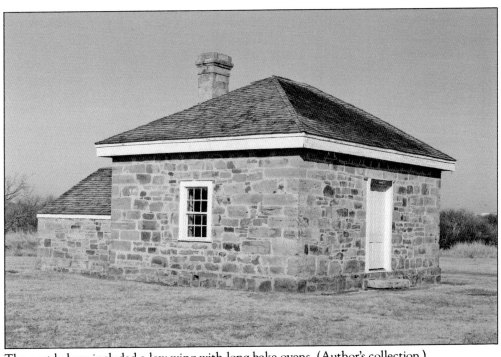
The post bakery included a low wing with long bake ovens. (Author's collection.)

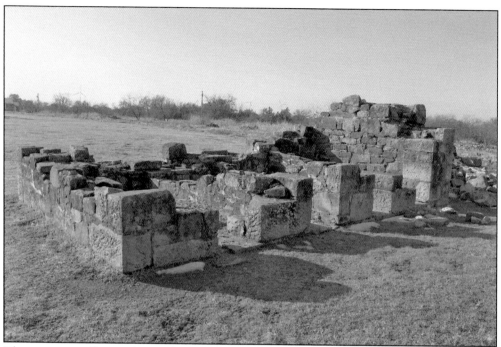

The stone guardhouse featured a guardroom for the officer of the guard and his sentinel command, as well as a prisoner confinement section with four narrow, solitary, unheated cells. (Author's collection.)

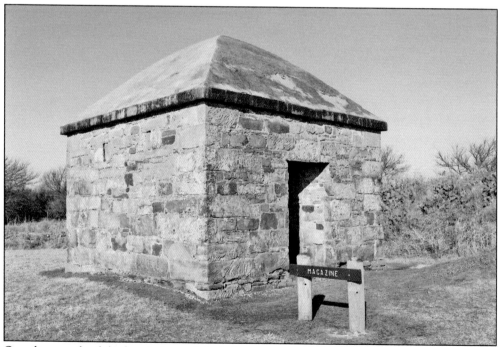

On a line north of the hospital stood the bakery, guardhouse, and—as far as possible from the main post—the powder magazine. (Author's collection.)

One of three new posts established in 1867, Fort Griffin was built on a plateau 100 feet above the Clear Fork of the Brazos. Overlooking a major Comanche war trail, the post promptly engaged in patrols and pursuits. Soldiers were housed in four rows of frame huts, 13 feet long and eight feet wide. Most other buildings were of frame or picket construction, and some were roofed only with canvas. (Author's collection.)

A few of the squad huts have been reconstructed on their small stone foundations. Designed for six soldiers, each hut had a fireplace and chimney on the wall opposite the door. Fort Griffin was a busy post, and when the huts were filled, tents were pitched for additional troopers. (Author's collection.)

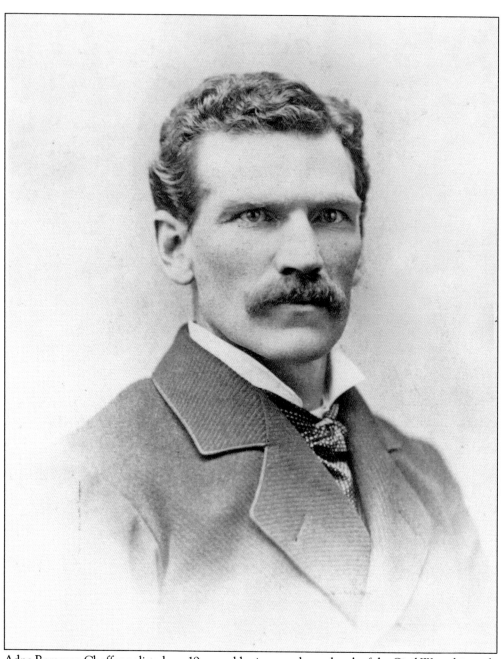

Adna Romanza Chaffee enlisted as a 19-year-old private at the outbreak of the Civil War, ultimately rising to Army chief of staff during a 45-year military career. As a member of the 6th Cavalry, he fought in 50 engagements during the Civil War, twice suffering wounds. The 6th Cavalry was sent to Texas after the war. Captain Chaffee, stationed at Fort Griffin in 1868, launched a charge against Comanche raiders, killing seven braves and routing the rest. Operating out of Fort Richardson in 1870, he led a 15-mile pursuit, and during the Red River War in 1874, Chaffee commanded a charge against perhaps 600 warriors. Twice, he was brevetted for action in Texas, and during one charge, Chaffee shouted to his troopers, "If any man is killed, I will make him a corporal!" (Courtesy of the National Archives and Records Administration.)

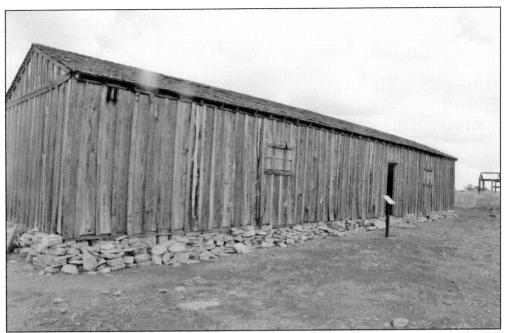

One of the four mess halls at Fort Griffin has been reconstructed. Even the hospital, usually the largest and most substantial building on the post, was of frame construction at Fort Griffin. Only a half-dozen stone structures were built at the large post. (Author's collection.)

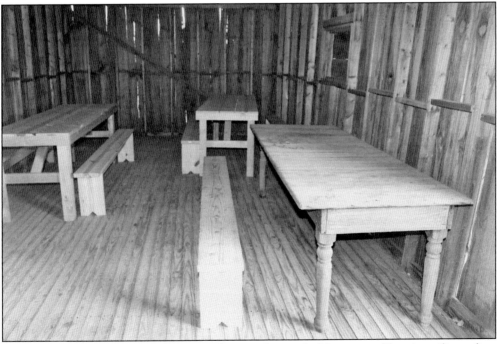

Furnishings in frontier mess halls were as basic as the meals. Mainstays of frontier military diets were salt, bacon, baked beans, hardtack, beef, stew, hash, and coffee, along with condiments such as salt, molasses, vinegar, and brown sugar. Hunting parties often supplied game, while vegetable gardens were tended by soldiers who were excused from other duties. (Author's collection.)

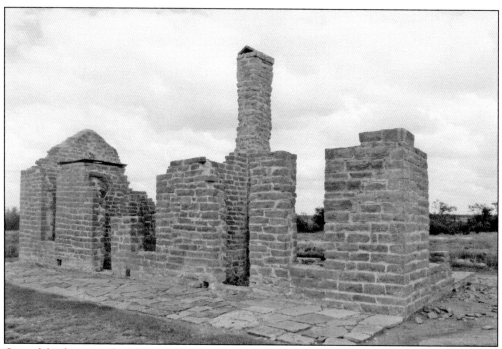

One of the few stone buildings at Fort Griffin was post headquarters. There were two rooms, and a chimney in the dividing wall provided heat in both rooms. (Author's collection.)

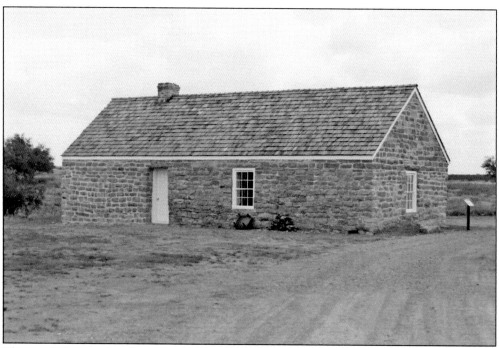

The post bakery, with its long ovens, also was of stone construction. Each soldier was allotted an 18-ounce loaf of bread daily. (Author's collection.)

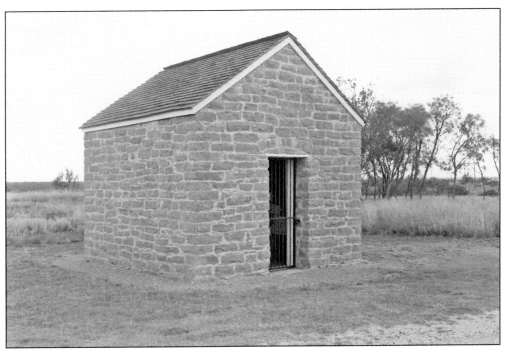

The powder magazine, of course, was tightly built of stone. (Author's collection.)

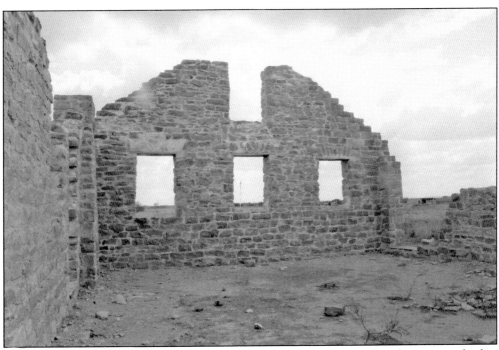

At the sutler's store, soldiers could buy such extra food as sardines, canned oysters, and other delicacies. But soldiers with money to spend usually left "Government Hill" for the "Flat" below, where a wolf howl of a town, called Fort Griffin, offered whiskey, gambling, and soiled doves, along with brawls and gunplay. (Author's collection.)

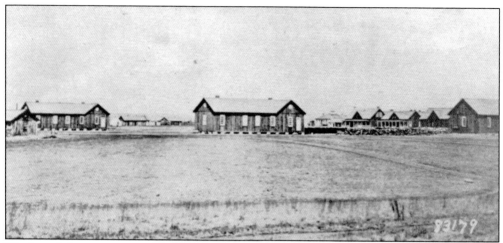

The last of the new outposts built after the Civil War was Fort Elliott, established in 1875 in the Texas Panhandle. Fort Elliott was designed for six companies, and the parade ground measured 650 feet by 450 feet. The presence of Fort Elliott at the close of the Red River War insured that there would be no further hostilities in the region. (Courtesy of the National Archives and Records Administration.)

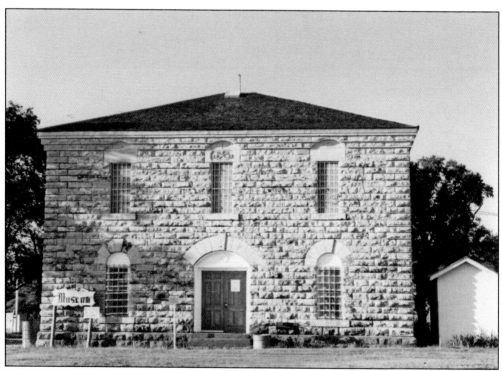

About a mile south of Fort Elliott, a rowdy town took shape named, at first, Hidetown, but later Mobeetie. In 1876, Bat Masterson killed a soldier in a saloon fight, but Masterson was wounded and his lady friend also was slain. There were a dozen saloons by the 1880s and a population of 400. A stone jail opened in 1889, although that year Fort Elliott was abandoned. (Author's collection.)

Five

Post–Civil War Rebuilding

When the US Army returned to the Texas frontier in 1867, three new outposts—Forts Concho, Richardson, and Griffin—were strategically placed to spearhead campaigns against Comanches and Kiowas. But the Army also planned to reoccupy and rebuild several of the older frontier forts. Several of the early posts remained closed, but forts at key locations were renovated and expanded.

Fort Davis, on the California Trail in far West Texas, was established in 1854, and flimsy picket structures were built in the shelter of a box canyon. In 1867, Lt. Col. Wesley Merritt reopened Fort Davis, moving the post out of the canyon (although the hospital and magazine were rebuilt at the original site). More than 60 adobe and stone buildings were erected, enough to accommodate 600 men. Fort Davis usually was garrisoned by buffalo soldiers, men from the 9th and 10th Cavalry or from the 24th and 25th Infantry. Fort Davis was the base of the Victorio Campaign of 1879–1880, the final significant operation of the Indian Wars in Texas.

Fort Stockton was not opened until 1859, and it closed because of the Civil War just two years later. Fort Stockton was reestablished as regimental headquarters of the 9th Cavalry, and the troops were often on patrol, as well as on escort duty for mail coaches and freighters.

Fort McKavett was founded in 1852 as Camp San Saba. The post overlooked the San Saba River, and there was a nearby spring, so water was never a problem at Fort McKavett. Also nearby was a Comanche war trail, and there were numerous pursuits and actions during the 1850s. When the Army returned to Fort McKavett in 1868, only one building was still usable, and the garrison was under canvas until the next year. But Col. Ranald Mackenzie took command of Fort McKavett in 1869, and the pace of construction rapidly accelerated. Soon, Fort McKavett was called the "beautiful little post on the San Saba."

In 1852, two companies of the 1st Infantry Regiment established Fort Clark at Las Moras Springs. The springs was a campsite on a Comanche war trail into Mexico. The new outpost was strategically positioned to protect the military road from San Antonio to El Paso and to defend against depredations emanating from either side of the Rio Grande. After the Civil War, the busy post was re-garrisoned and actions against war parties continued from Fort Clark. Because of border troubles, Fort Clark continued into the 20th century. Until late in 1941, Fort Clark was the base of the 5th Cavalry (originally the 2nd Cavalry of the 1850s). During World War II, the Army's last horse-mounted unit, the 2nd Cavalry Division, was assigned to Fort Clark. By the end of World War II, all cavalry units were mechanized, and Fort Clark was deactivated in 1946.

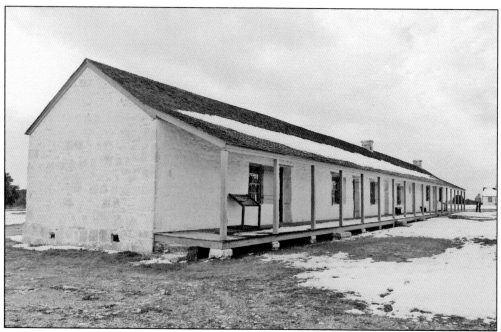

Established in 1852 as Camp San Saba, the outpost later was renamed Fort McKavett. A stone barracks built in 1853 served the fort for most of its life. The post was located just above a spring, which provided good drinking water. A limekiln was developed nearby for building stone, and a road was built down to this important site. (Author's collection.)

A building stone records that this barracks was built for Company B of the 8th Infantry in 1853. The labor was provided by the soldiers of Company B. A stonemason would be hired, along with a carpenter or two, but the workforce was enlisted men. (Author's collection.)

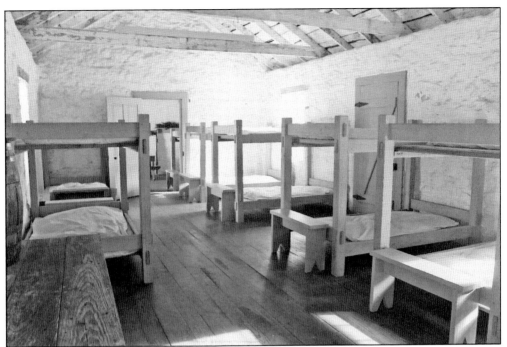

During the 1850s, company quarters, as in barracks of the 1700s, featured bunks that accommodated four soldiers. Two men slept side by side in the lower bed, while two more slept above. (Author's collection.)

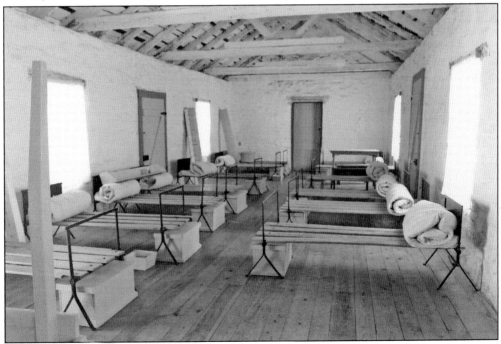

Camp San Saba was abandoned in 1859 but reoccupied in 1868 as Fort McKavett. The fort was expanded and upgraded. By the 1870s, troopers had individual cots in company barracks, and footlockers also were becoming common. (Author's collection.)

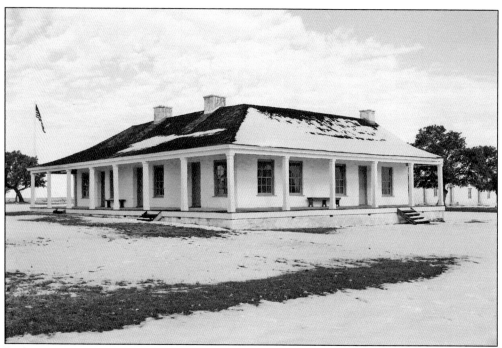
Built in 1852 as a one-room command office, Fort McKavett's headquarters was greatly expanded after the Civil War. There were regimental offices, a telegraph room, and a post library. (Author's collection.)

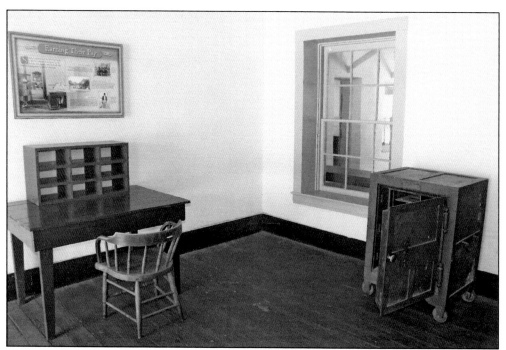
One of the offices at headquarters contained a safe, which had cash to be dispersed at the discretion of the commanding officer. (Author's collection.)

Eugene Beaumont graduated from West Point in May 1861, at the beginning of the Civil War. He fought at Bull Run, Gettysburg, the Wilderness, and numerous other actions. Later in the war, as a brevet colonel of the 4th Cavalry, Beaumont led assaults that earned him a Medal of Honor. He remained with the 4th Cavalry after the war as captain of Company A. Captain Beaumont and his men reestablished Fort McKavett in March 1868, although the 1850s buildings were in ruins and the command had to go under canvas. In 1874, Captain Beaumont fought at the Battle of Palo Duro Canyon with the 4th Cavalry but soon was assigned to West Point as instructor of cavalry tactics. He served as inspector general of Texas from 1888 until his retirement in 1892. (Courtesy of Fort McKavett State Historic Site.)

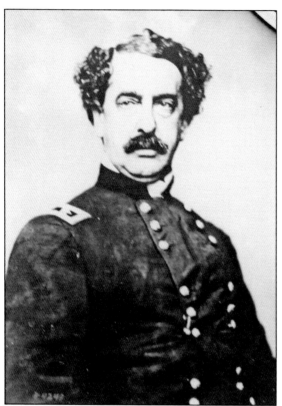

Abner Doubleday was a graduate of West Point who was wounded at Gettysburg. Promoted to the regular Army rank of colonel, he came to Texas in 1871 as commandant of Fort McKavett. Colonel Doubleday commanded the 24th Infantry Regiment of buffalo soldiers. According to legend, Doubleday invented the game of baseball. He did not, but the sport was played widely at military outposts across America. (Courtesy of Fort McKavett State Historic Site.)

The commanding officer's quarters was the only two-story building at Fort McKavett. After the post was deactivated, the house was a rancher's residence until it burned about 1940. Today, the stone walls still stand. (Courtesy of Fort McKavett State Historic Site.)

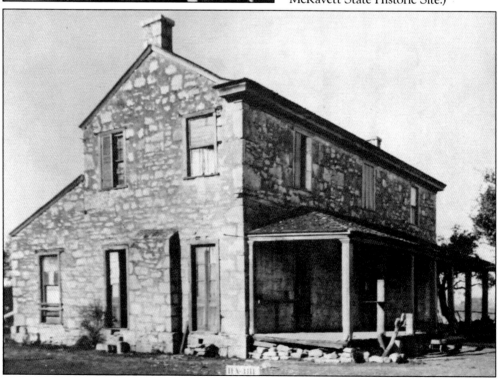

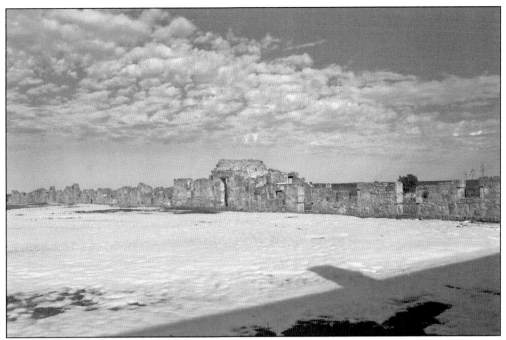

In the 1850s, three separate company barracks were built on the north side of the parade ground, facing the five one-room houses of Officers' Row. After the Civil War, each of the five officers' residences was greatly expanded, while the three barracks buildings were connected in 1872. The stone barracks thus became the longest military building west of the Mississippi River. (Author's collection.)

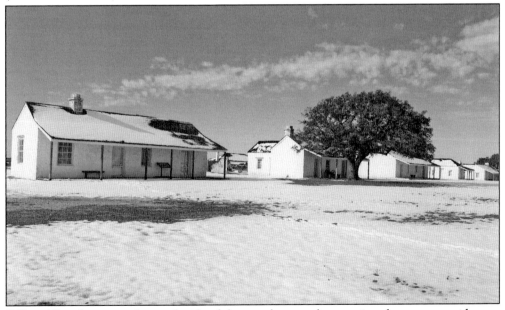

Officers' Row began on the south side of the parade ground as a series of one-room residences. After the Civil War, these buildings were expanded into comfortable homes. With the addition of houses for higher-ranking officers, these structures were used for lieutenants and their families or for bachelor officers. (Author's collection.)

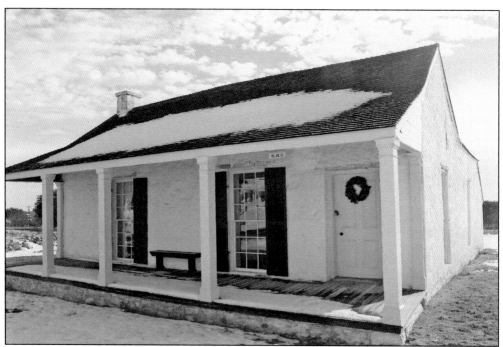

A cluster of spacious residences was erected near headquarters and just west of the parade ground. The largest was the two-story commanding officer's quarters. Nearby was a duplex intended for the next two ranking officers. Fort McKavett was built as a four-company post, and the four company captains had access to a row of four residences (one is shown above). (Author's collection.)

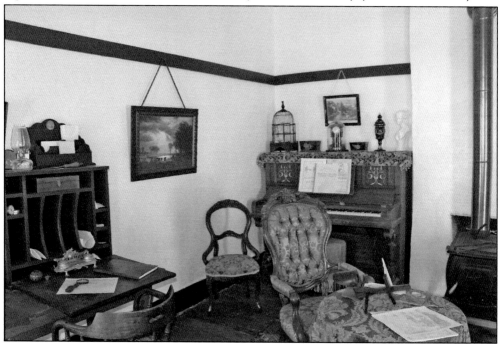

The parlor in a captain's house features a piano, along with numerous Victorian "notions." (Author's collection.)

This captain's bedroom includes a rocking chair and a child's bed. (Author's collection.)

A captain's wife dominated this front bedroom with a dress mannequin, vanity table, and dressing screen. (Author's collection.)

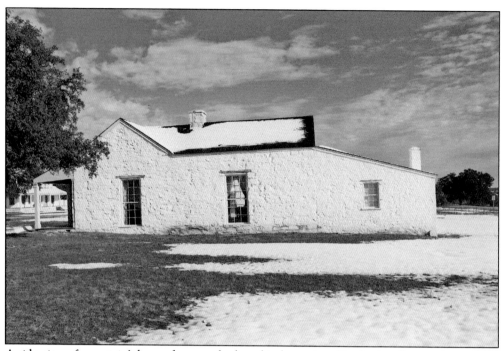

A side view of a captain's house features the long kitchen wing. (Author's collection.)

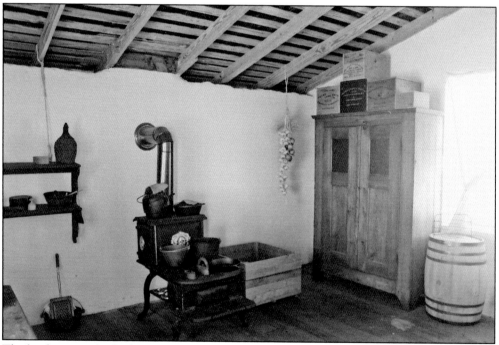

The kitchen was the back room in the rear wing. Note the flatiron staying warm on the stove. (Author's collection.)

A dining room table is tastefully set for six places. Captains, along with majors and other ranking officers, had important social responsibilities for officers of similar rank, as well as for lieutenants of their company. (Author's collection.)

A rear room in a captain's house has been utilized as the captain's office, including a small table and chairs for lunch or breakfast. (Author's collection.)

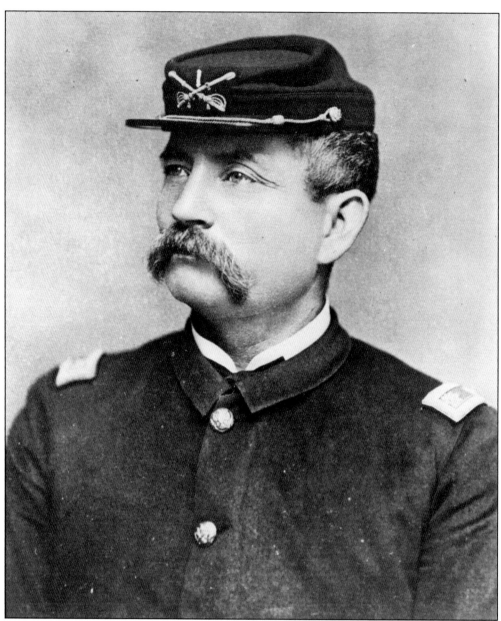

Henry Carroll distinguished himself for four decades in the US Army. Enlisting in the artillery in 1859, Carroll fought throughout the Civil War and was awarded a cavalry commission. After the war, Carroll turned to the newly formed black regiments for promotion, obtaining a captaincy in the 9th Cavalry. In December 1867, near the Eagle Springs Stage Station in Texas, Captain Carroll led his company in a furious charge to rescue a fleeing stagecoach from pursuit by a large Apache war party. In 1869, Captain Carroll rode out of Fort McKavett at the head of nearly 100 men in pursuit of Kiowa raiders. After 42 days in the field, Carroll led a charge against 200 lodges. A wild running fight ensued for eight miles, with 20 warriors shot and all equipment and supplies captured or destroyed. Following long service in the Indian Wars, Carroll was promoted to brigadier general of volunteers during the Spanish-American War. (Courtesy of the National Archives and Records Administration.)

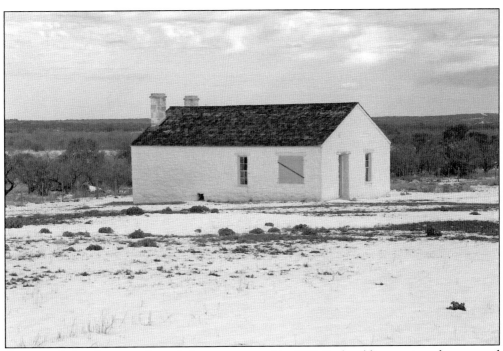

An expanded and improved post bakery was erected in 1874. Each soldier was issued one pound of bread or hardtack daily. (Author's collection.)

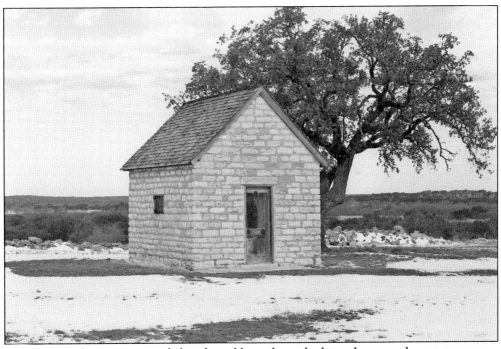

The stone powder magazine was below the stables and corrals, distantly removed—as customary—from the main post. As part of a Texas State Historic Site, the magazine now stands adjacent to the parade ground, for the convenience of visitors. (Author's collection.)

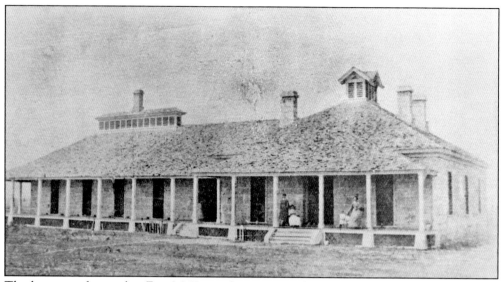

The large post hospital at Fort McKavett later was used as a ranch house, and today, it is a museum. Note the ventilation device at the top of the roof. (Courtesy of Fort McKavett State Historic Site.)

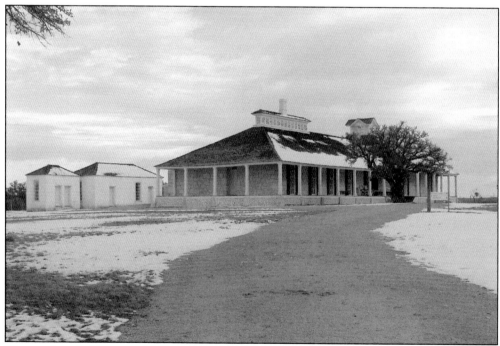

The post hospital is pictured following a snowstorm. The small building at left is the "sink," while the larger structure beside it is the morgue. (Author's collection.)

In the morgue, or deadhouse, behind the hospital, two simple government coffins await permanent residents. (Author's collection.)

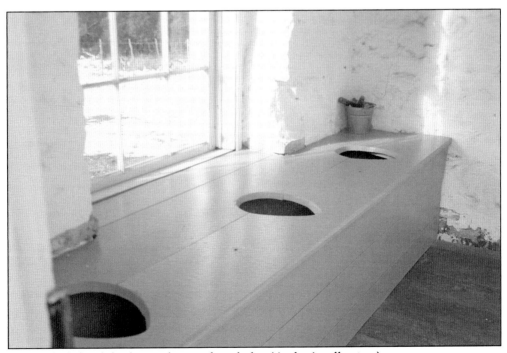
The "sink" behind this hospital was a three-holer. (Author's collection.)

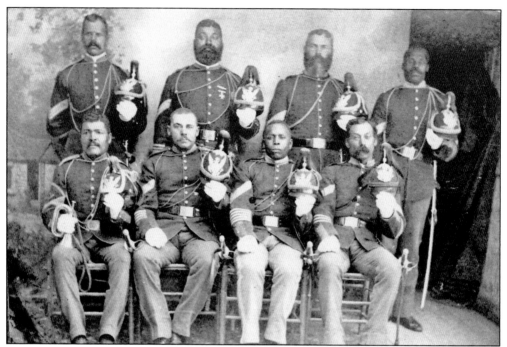

A group of sergeants poses proudly in dress uniforms. The bugler at left brandishes his bugle as well as his dress helmet. An infantry regiment responded to a dozen bugle calls, while cavalry had 20 calls. (Courtesy of Fort McKavett State Historic Site.)

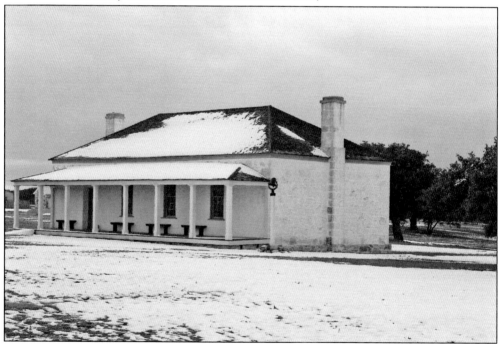

Built in 1874, the post school also was used as a chapel for religious services. Another use was for dances and other social events. After the post was discontinued in 1883, the building served as a public school until 1956. Note the school bell. (Author's collection.)

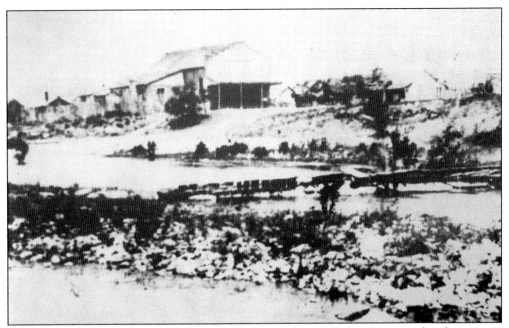

A hog ranch developed to the east of Fort McKavett and was called Scabtown. After the post was deactivated in 1883, civilians moved into many of the abandoned buildings. Indeed, the school was used by children until 1956. The community of about 150 was known as Fort McKavett. (Courtesy of Fort McKavett State Historic Site.)

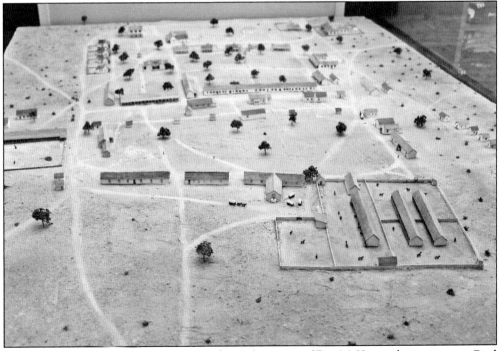

This scale model in the hospital/museum shows the extent of Fort McKavett during its post–Civil War reconstruction and expansion. The view is from the north, with cavalry stables and the quartermaster corral in the foreground. (Author's collection.)

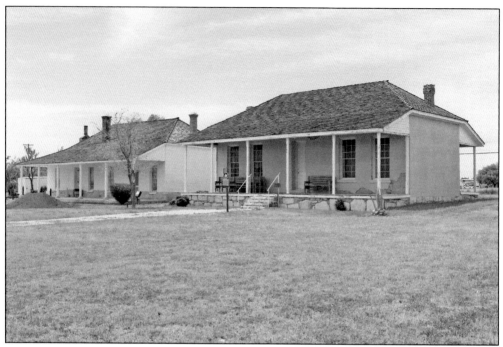

Fort Stockton was established in 1859 to protect the southwestern route for mail service, freighters, and travelers. Within two years, the outpost was abandoned because of the Civil War, and the US Army did not return until 1867. The original buildings were in ruins, but a four-company post was erected near the 1859 site, including officers' housing on the west side of the parade ground. (Author's collection.)

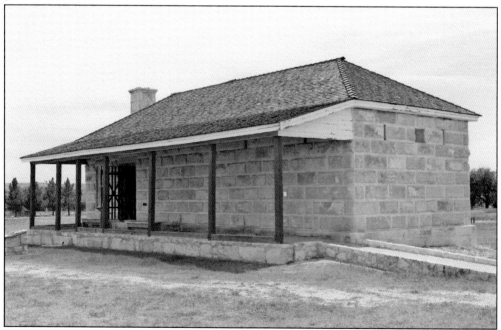

A stone guardhouse was built at the south end of the parade ground. The 24-hour guard headquartered in the office and the adjoining cells were secure. (Author's collection.)

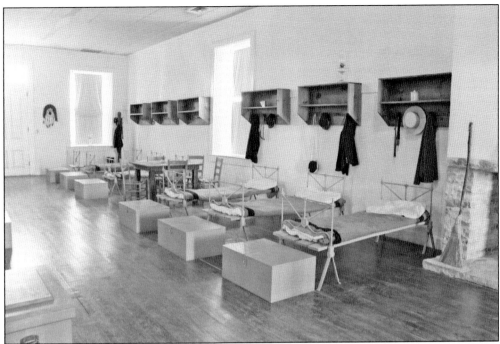

Col. Edward Hatch utilized Fort Stockton as regimental headquarters of the 9th Cavalry of buffalo soldiers. Company barracks were built with stone foundations and thick adobe walls. (Author's collection.)

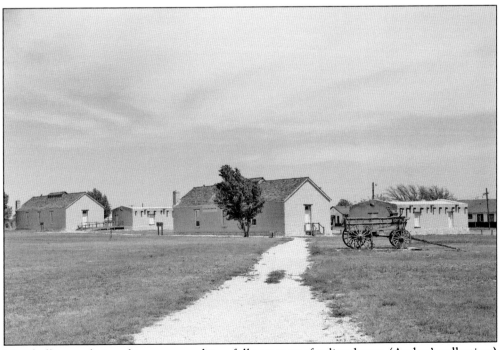

Mess halls were designed to accommodate a full company of enlisted men. (Author's collection.)

The most popular and widely celebrated holiday of the Old West was the Fourth of July. On July 4, 1882, Capt. George A. Armes, of the 10th Cavalry, staged a grand celebration at Fort Stockton, persuading the commanding officer to invite area ranchers and cowboys and to excuse the entire garrison from duty. "My company put up a greased pole [for a greased pole climb] and had a pig shaved and greased [for a greased pig contest]." A wheelbarrow race and a sack race were staged, along with "several splendid horseraces." Most importantly, there was "plenty of beer" for all. Footraces and three-legged races also were staples of such celebrations. (Above, author's collection; below, courtesy of Historic Fort Stockton.)

Christmas was universally observed at frontier posts. Decorations featured trees and paper chains, shown above in a company barracks at Fort McKavett and below in an officer's home at Fort Concho. Christmas dinner, whether in company quarters or at a banquet for officers and their families, was the subject of detailed planning. Nuts, raisins, dried fruits, cigars, and bottles of liquor were stockpiled. Wild plum jelly was put up to replace cranberries, and for a couple of days before Christmas, baking produced cakes and loaves of bread. Hunting parties brought in deer, antelope, and turkey. Christmas dances often were held. Other post-wide celebrations included Washington's Birthday, Thanksgiving, Memorial Day, and the occasional visit of a general. (Both, author's collection.)

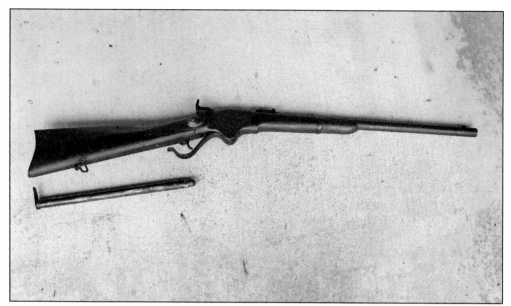

The Spencer carbine was a superb cavalry weapon, a lever-action repeating rifle that carried seven copper case, rimfire cartridges in the magazine tube and an eighth round in the chamber. The magazine tube was inserted into the rifle stock, and the lever, which produced rapid-fire, doubled as the trigger guard. (Courtesy of Dennis LaGrone and Ashley LaGrone Brewster.)

Field artillery pieces were much larger and far heavier than mountain howitzers. Each artillery piece required a limber and a six-horse gun team. Such artillery was of little use in the field against mounted Comanche and Kiowa warriors. But most Texas forts had at least one artillery piece on the parade ground, utilized as a signal gun if not on campaigns. (Exhibit at Fort Concho, author's collection.)

The 12-pounder mountain howitzer was designed to be packed on horses or mules through hilly or mountainous terrain. The brass tube was only 33 inches long and weighed 220 pounds. The wheels were 38 inches in diameter and weighed 65 pounds apiece, while the carriage was 61 inches long and weighed 157 pounds. Ammunition was carried in narrow boxes that held eight rounds and weighed 112 pounds packed. One box was strapped to each side of a packsaddle. A pack animal could carry 250 to 300 pounds 20 miles per day. One pack animal carried the wheels, carriage, and implements, while another animal carried the tube. Gun crews were trained to unpack, reassemble, and fire a round in one minute. (Exhibit at Fort Martin Scott, author's collection.)

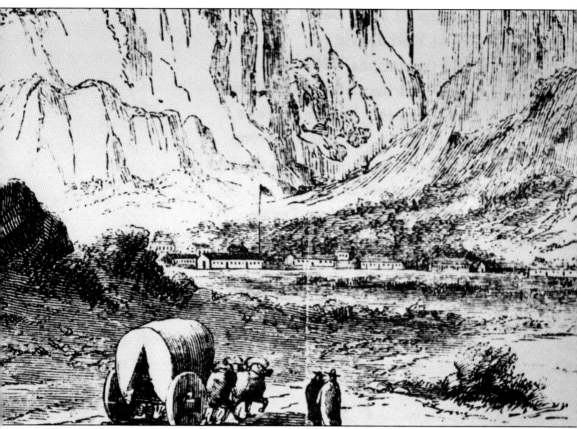

In an 1861 drawing, a wooden-wheeled, ox-drawn freight cart approaches Fort Davis, nestled into a box canyon at the eastern base of the Davis Mountains. In 1854, Secretary of War Jefferson Davis ordered the establishment of an outpost to guard the Trans-Pecos region of the San Antonio–El Paso Road. The post was located on Limpia Creek, an oasis in an enormous desert. The remote garrison patrolled the road, escorted stagecoaches, and campaigned against Comanche and Apache war parties. The fort was expanded into a regimental post. Among the regiments that served at Fort Davis were the 9th and 10th Cavalry of buffalo soldiers as well as all four regiments of buffalo soldier infantry. (Detail of sketch in *Harper's Weekly*, March 16, 1861, and reproduced in the booklet *Fort Davis, National Historic Site* by Robert M. Utley and published by the National Park Service in 1965.)

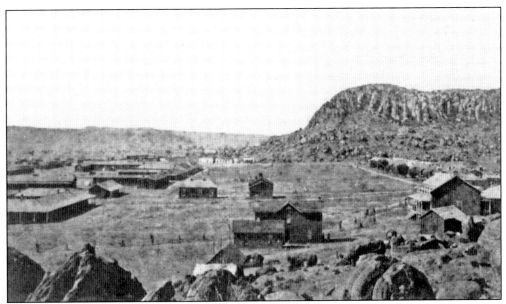

When Fort Davis was reoccupied by the Army in 1867, the post was expanded by moving to the east (left) from the confines of the box canyon, out of view to the right. This view was taken from the north in 1885, when Fort Davis was at the height of its development with more than 100 buildings. Headquarters stands just left of center with a light-colored roof. (Courtesy of the National Archives and Records Administration.)

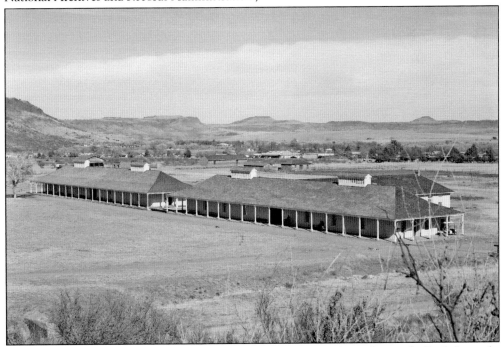

Two company barracks are visible in this view of Fort Davis from the south. Each barracks was divided into two platoon rooms, with a mess hall in the rear. Behind these barracks stand the cavalry stables and the quartermaster corral. (Courtesy of the National Archives and Records Administration.)

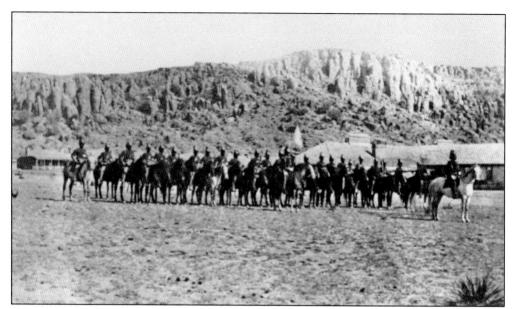

From 1867 until 1875, an element of the 9th Cavalry was stationed at Fort Davis, where a mounted company stands on dress parade in 1875. The 9th Cavalry was commanded by Col. Edward Hatch from 1866 until his death in 1889. (Courtesy of the National Archives and Records Administration.)

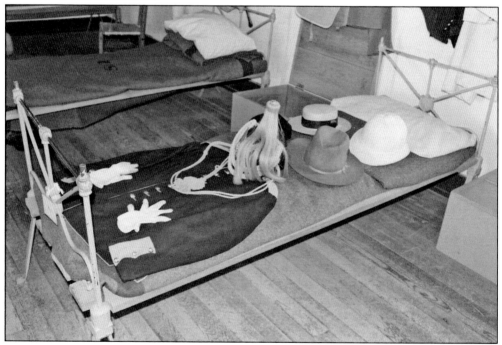

Dress uniforms were worn only at retreat and for special ceremonies. Along with the plumed dress helmet, other headwear arrayed on the cot includes a felt campaign hat, a pith helmet, and a straw boater. Enlisted men were given a modest clothing allowance. But most soldiers managed to stay under budget, and upon their discharge, any unused clothing allowance money was paid in a lump sum. (Author's collection.)

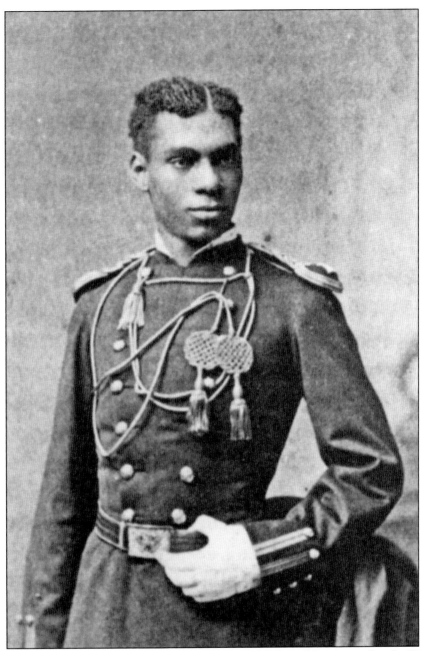

Lt. Henry O. Flipper was born a slave in Georgia, attended Atlanta University after the Civil War, and in 1877 became the first African American to graduate from West Point. Flipper endured racial harassment at West Point and after receiving his commission. Assigned to the 10th Cavalry, Flipper served in Texas at Forts Concho, Elliott, Quitman, and Davis. There were rumors of impropriety with a white woman and in 1881 charges were brought against him regarding missing quartermaster funds. Although he was cleared at a court-martial, a different charge was made, and in 1882, Flipper was dismissed from the service. He had a long career as an engineer, and decades after his death, he was given an honorable discharge. Today, there is a bust of Flipper at West Point. (Courtesy of the National Archives and Records Administration.)

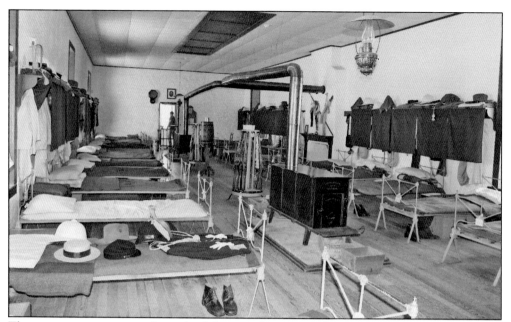

There was a separate room for each of the two platoons in all company barracks at Fort Davis. Soldiers usually remained with the same company throughout their five-year enlistment—or enlistments. The company barracks and mess hall became home, featuring iron bedsteads, carbine racks, and cast-iron stoves for winter heating. (Author's collection.)

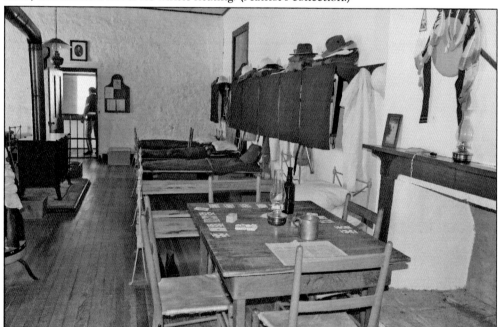

A card table beside the fireplace offered recreation possibilities during evenings in the barracks. Although gambling was prohibited, small stakes games sometimes took place. Checkers was a popular pastime. Some men were singers, and others were jokesters. Some soldiers read, and some kept a Bible in their kit. But others, usually old veterans, groused incessantly, and some were petty thieves. (Author's collection.)

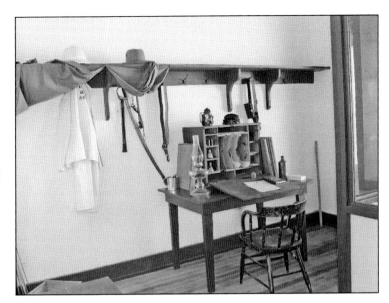

The orderly room in the company barracks was the domain of the first sergeant. Often the top sergeant was joined in the office by the captain in command of the company or by one of the troop's two platoon officers, a first or second lieutenant. Not infrequently, in the absence of the captain, the company was commanded by the first lieutenant. (Author's collection.)

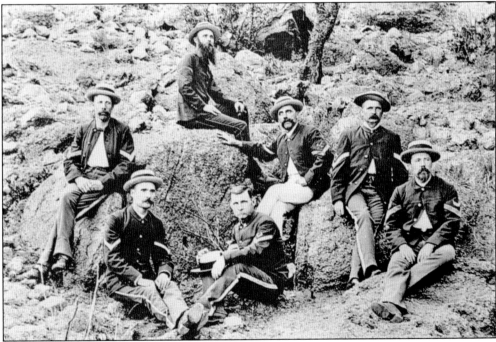

Several prominent noncommissioned officers gathered for a photograph at Fort Davis in 1887. There were two first sergeants and the post quartermaster sergeant. Hospital steward Jacob Appell sits atop the boulder, while Commissary Sgt. Thomas Forsyth is at far left. Wounded during the Civil War, Forsyth earned the Medal of Honor. He suffered another wound while leading a daring action to rescue his commanding officer in an 1876 action. (Courtesy National Archives and Records Administration.)

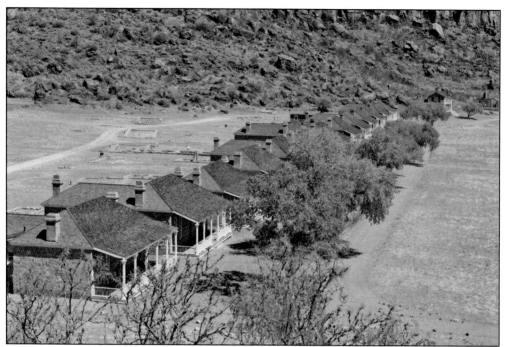

Construction of Officers' Row was begun by Lt. Col. Wesley Merritt, who directed the reoccupation of Fort Davis in 1867. There would be white picket fences in front of each house, along with a separate kitchen, privy, and other outbuildings behind each officer's quarters. Behind the commanding officer's quarters was a special stable for the mounts of the commanding officer. (Author's collection.)

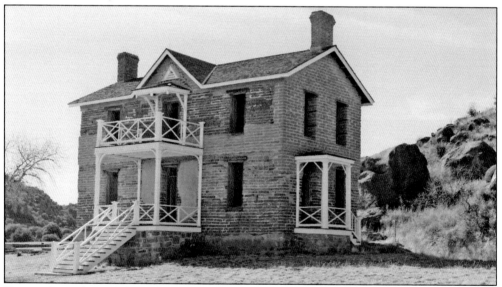

During the mid-1880s, four two-story houses were built at the north end of Officers' Row. The occupants would hire a "striker," an enlisted man who policed the quarters and took care of laundry. Commissary Sgt. Thomas Forsyth, one of the most notable noncommissioned officers at Fort Davis, lived with his large, rambunctious family (nicknamed "The Tribe") for several years in one of these quarters. (Author's collection.)

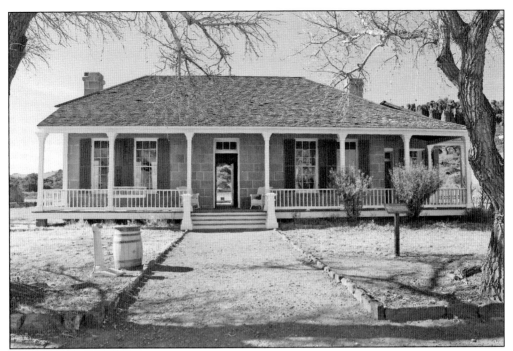

The commanding officer's quarters at Fort Davis stood in the center of Officers' Row. The central hallway served as a breezeway in warm weather. The commander officers' quarters was home for Col. Benjamin Grierson and his family for three years. (Author's collection.)

Benjamin Grierson enlisted as a Union private when the Civil War erupted. Within a year, he soared to the colonelcy of a cavalry regiment, and by the end of the war, Grierson had risen to major general. Soon after the Civil War, he was assigned to organize the 10th Cavalry, a regiment he would serve as colonel for a quarter of a century, from 1866 to 1890. (Courtesy of the National Archives and Records Administration.)

Benjamin Grierson was a music teacher before the Civil War, and he maintained a well-equipped music room for his family. Colonel Grierson organized a regimental band for the 10th Cavalry, training several of the musicians himself. (Author's collection.)

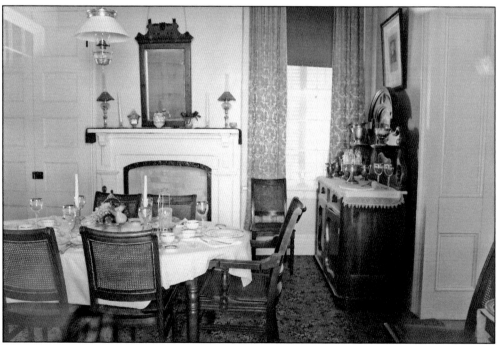

The commanding officer's quarters dining room was used not only for family meals, but also for entertaining other officers and their wives. (Author's collection.)

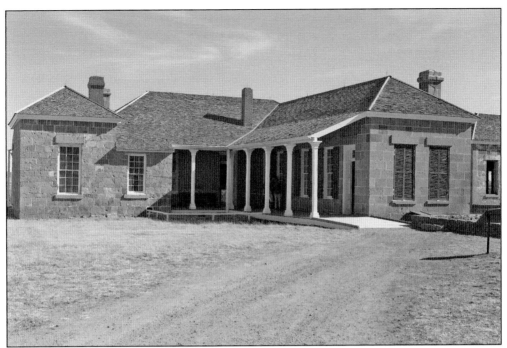
A back view of the commanding officer's quarters is dominated by a large rear wing, which enclosed a music room and a dining room. (Author's collection.)

The front parlor in the commanding officer's quarters led to the dining room at right. This view is from the central hallway. (Author's collection.)

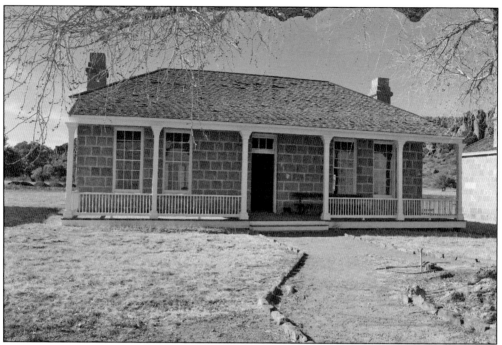

Most of the houses on Officers' Row followed this smaller design. Rank prevailed in officers' housing. If, for example, a bachelor major was transferred to the post, he could oust a married captain with six children. But the captain, in turn, could take the house of a first lieutenant and his family, and so on across Officers' Row. (Author's collection.)

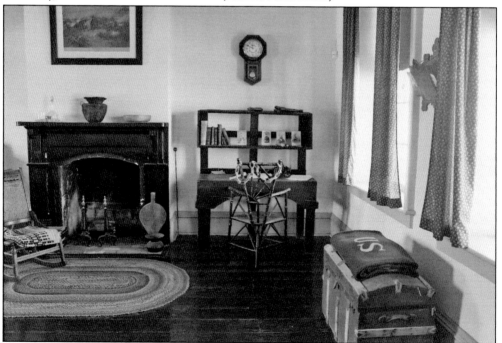

The parlor in a typical officer's house predictably was more modest than the commanding officer's quarters parlor. (Author's collection.)

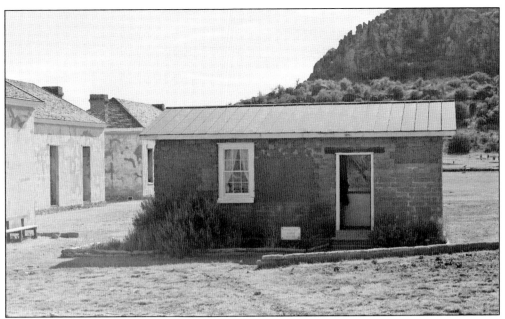

Kitchens on Officers' Row were located behind each house and were always separate structures. Cooking fires usually had to be maintained all day in order to prepare three meals, and if attached to the main house, the heat would have been unbearable during the long summer months. Also, if flames broke out in the kitchen, the single detached room was far easier to replace than the entire house. (Author's collection.)

The stone powder magazine at Fort Davis was located well behind the hospital and deep into the box canyon, so that an accidental ammunition explosion would not damage the main post. (Author's collection.)

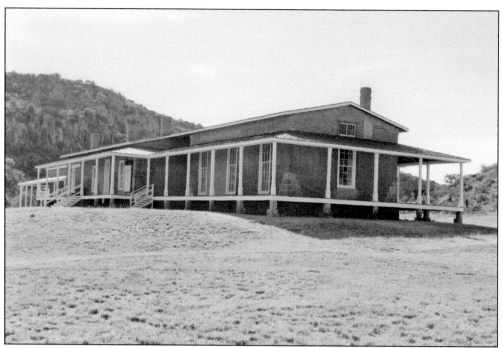

The post hospital was built in the box canyon where a fort of the 1850s was located. The central structure housed doctor's offices and a dining hall, while two long wings were each 12-bed wards. The medical supply building stands at right. (Author's collection.)

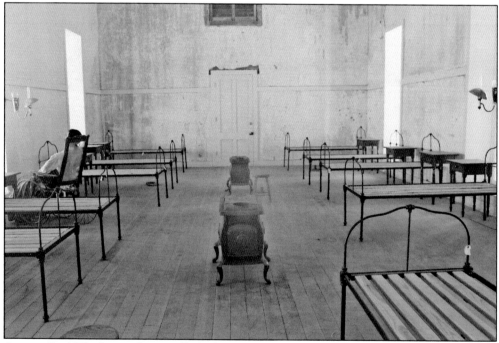

A post–Civil War hospital originally had only a single 12-bed ward. But sometimes as many as 500 men were stationed at Fort Davis, and in 1884, a second ward was added, creating a capacity of 24 beds. Out of view to the left stood the hospital steward's quarters. (Author's collection.)

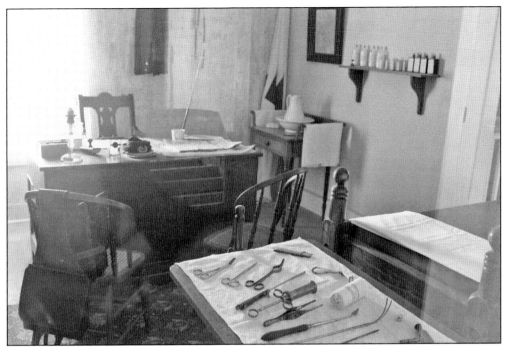

The post surgeon worked out of an office in the central section of the Fort Davis hospital. The surgeon at a frontier outpost usually was the only physician in the region, and he treated civilians as well as soldiers. The hospital steward, a sergeant, had first contact with those seeking medical help. The steward kept all records, dispensed medicines, and supervised nurses and cooks. (Author's collection.)

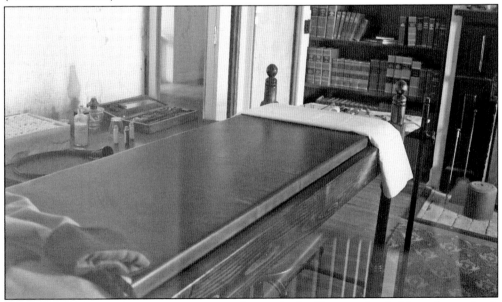

There was no hospital operating room, so the surgical table was wheeled into the patient's ward. A portable screen provided a modicum of privacy as the post surgeon performed surgery in the ward. Assisting "nurses" were soldiers who had only rudimentary medical training. (Author's collection.)

The front section of the large commissary storehouse has been reconstructed, and a typical freight wagon stands nearby. All food supplies—as well as equipment, uniforms, and weapons—had to be freighted almost 600 miles from San Antonio. The issue room and commissary sergeant's office occupied the front section, while stone foundations outline the warehouse in the rear. (Author's collection.)

Officers and civilian employees purchased food here at government cost plus transportation expenses. While enlisted men were provided rations, they also could visit the issue room and buy non-ration items to suit their tastes—and their wallets. An adjacent office was utilized for record-keeping by the commissary sergeant and a clerk. (Author's collection.)

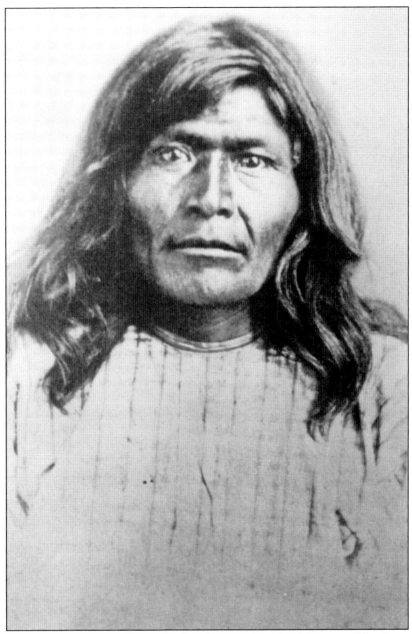

Victorio was an aggressive Apache war leader who raided in New Mexico and bordering Mexico during the late 1870s. In the summer of 1880, when pressured by a large Mexican force, Victorio slipped across the Rio Grande into West Texas. Col. Benjamin Grierson had anticipated this move, stationing buffalo soldiers at water holes throughout the arid region. On July 30, 1880, Victorio and 60 warriors attacked a prepared position at a water hole in Quitman Canyon. Grierson was in personal command, and after an hour of fighting, the Apaches withdrew with seven dead warriors. A week later, Colonel Grierson led a forced march of 65 miles and set another trap at the water hole at Rattlesnake Springs. Victorio retreated toward Mexico, where he was killed two months later. Twice, Grierson and his buffalo soldiers had met and thwarted Victorio—a feat accomplished by no one else. (Author's collection.)

In 1852, two companies of the 1st Infantry established an outpost that became known as Fort Clark. The post was located north of the Rio Grande at Las Moras Springs, long a stopping point on a branch of the Great Comanche War Trail into Mexico. The officers' residence shown here was built in the 1850s and was utilized throughout the long life of Fort Clark. (Author's collection.)

Comanche warriors were expert at stealing horses, and at Fort Clark, a stone corral with loopholes was erected to protect cavalry mounts. (Author's collection.)

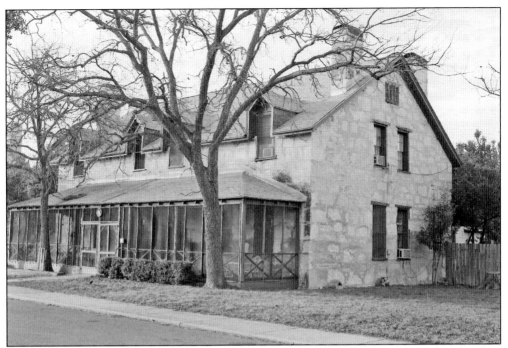

This two-story limestone duplex was built in 1888 to house two senior officers and their families. During the 1930s, Col. George S. Patton, commander of the 15th Cavalry, resided here with his family. (Author's collection.)

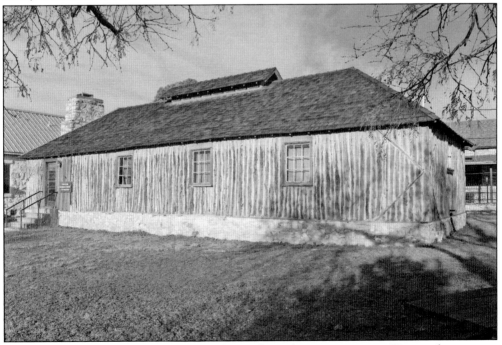

Palisado buildings of picket construction (vertical posts) were common at Texas military posts. This palisado structure was built in 1869 as a mess hall for a nearby limestone company barracks. (Author's collection.)

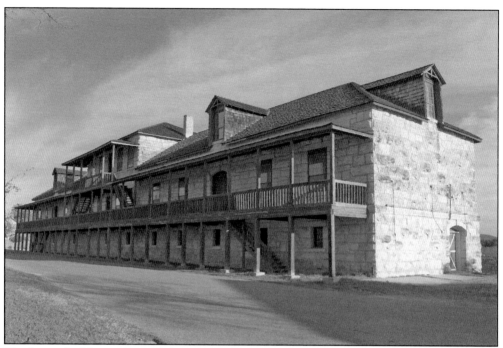

The largest building at Fort Clark was a commissary storehouse, erected in 1882. In 1952, seven years after Fort Clark was deactivated, this impressive structure was utilized as a military backdrop for the Charlton Heston movie *Arrowhead*. (Author's collection.)

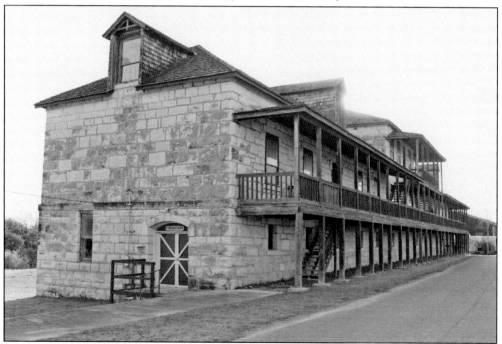

After the 1882 commissary impersonated officers' quarters in *Arrowhead*, other Western movies began to be filmed in and around old Fort Clark. The most famous motion picture was John Wayne's *The Alamo*, filmed at Alamo Village several miles out of town. (Author's collection.)

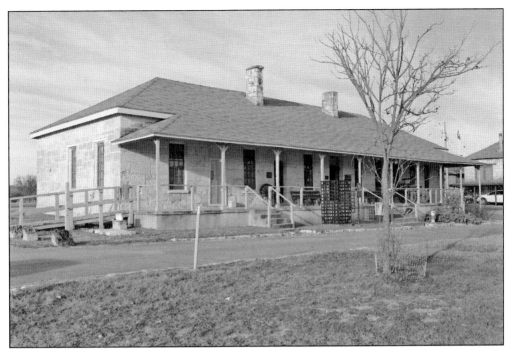

The guardhouse at Fort Clark was built during the 1870s, a period when the busy post was undergoing expansion. Today, the old guardhouse serves as a museum. (Author's collection.)

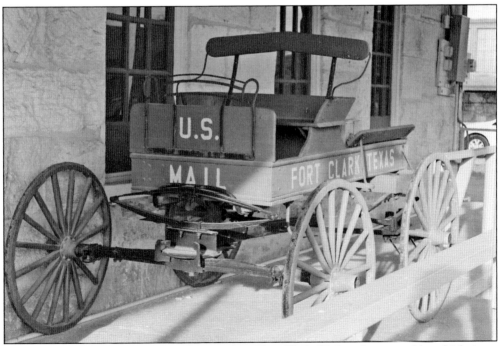

A horse-drawn mail wagon made the rounds at Fort Clark. Today, the venerable vehicle is on display at the guardhouse museum. (Author's collection.)

Operating out of Fort Richardson, Col. Ranald Mackenzie led his first campaign into Comancheria in 1871. During one action, he was struck in the thigh by an arrow—his seventh combat wound. The next fall, he led 248 men into West Texas, destroying a large village and killing 50 warriors during the battle. By the next year, 1873, the 4th Cavalry had been transferred to Fort Clark to deal with war parties from Mexico who raided into Texas then retreated back across the Rio Grande. Mackenzie pushed his troopers through grueling training, while awaiting an opportunity to put into effect oral orders from Gen. Phil Sheridan. When word came in April 1873 that a raiding party had struck a nearby ranch, Mackenzie led 378 men into Mexico and destroyed three villages before withdrawing back to Texas, having ridden 140 miles in 38 hours. (Courtesy of the National Archives and Records Administration.)

The entrance to Fort Clark is dominated by a bronze statue of a cavalry mount with an empty saddle. The "empty saddle" statue traditionally commemorated cavalrymen who have fallen in battle. At a trooper's funeral service, his horse is saddled and his boots are reversed in the stirrups. Since Fort Clark was the US Army's first cavalry base, the empty saddle statue honors all troopers who were slain during the Indian Wars. Indeed, for Texas, Fort Clark's empty saddle statue figuratively salutes not only cavalry troopers but also Texas Rangers and Dragoons, as well as Comanche and Kiowa horseback warriors. The bronze cavalry mount stands impressively on post at the nation's last US cavalry base and can be seen entering or leaving Fort Clark. (Both, author's collection.)

Discover Thousands of Local History Books Featuring Millions of Vintage Images

Arcadia Publishing, the leading local history publisher in the United States, is committed to making history accessible and meaningful through publishing books that celebrate and preserve the heritage of America's people and places.

Find more books like this at
www.arcadiapublishing.com

Search for your hometown history, your old stomping grounds, and even your favorite sports team.

Consistent with our mission to preserve history on a local level, this book was printed in South Carolina on American-made paper and manufactured entirely in the United States. Products carrying the accredited Forest Stewardship Council (FSC) label are printed on 100 percent FSC-certified paper.